Jeff Smith's LIGHTING
FOR OUTDOOR & LOCATION PORTRAIT PHOTOGRAPHY

AMHERST MEDIA, INC. ■ BUFFALO, NY

JEFF SMITH is a professional photographer and studio owner from central California. His numerous articles have appeared in *Rangefinder, Professional Photographer,* and *Studio Photography & Design* magazines. Jeff has been a featured speaker at the Senior Photographers International Convention, as well as at numerous seminars for professional photographers. He has written numerous books, including *Outdoor and Location Portrait Photography, Posing for Portrait Photography, Professional Digital Portrait Photography,* and *Success in Portrait Photography,* all from Amherst Media. His commonsense approach to photography and business makes the information he presents both practical and very easy to understand.

Copyright © 2007 by Jeff Smith.
All rights reserved.

Published by:
Amherst Media, Inc.
P.O. Box 586
Buffalo, N.Y. 14226
Fax: 716-874-4508
www.AmherstMedia.com

Publisher: Craig Alesse
Senior Editor/Production Manager: Michelle Perkins
Assistant Editor: Barbara A. Lynch-Johnt
Editorial Assistance: Artie Vanderpool

ISBN-13: 978-1-58428-209-9
Library of Congress Control Number: 200937285

Printed in Korea.
10 9 8 7 6 5 4 3 2 1

TABLE OF CONTENTS

INTRODUCTION
TO LOCATION PORTRAITURE

Images taken outside of a studio are some of the most unique and personalized portraits that we can create. Contrary to what many photographers think, however, location portraits can be both efficient *and* profitable.

■ ADVANTAGES

Cost Savings. In our studio, we photograph nothing but high-school seniors. This requires a larger-than-normal variety of backgrounds, sets, and props. We have expensive sets from Off the Wall and Scenic Designs, countless painted backgrounds, and customized sets, and a Harley Davidson motorcycle. As I write this book, we are even in the process of buying a Dodge Viper for our seniors to be photographed with (although once in while it will be fun for me, too!).

All of these sets . . . all this money . . . and what is it for? They are all the result of an attempt to create unique environments for seniors to take portraits in. Yet, while I love my sets and the ease of working in the studio, there is a park right down the street from the studio with bridges, arches, and walkways that offer a depth I can't re-create in or around the studio. Best of all, it's mine anytime for a $2.00 admission fee. You definitely can't beat that for economy!

Greater Personalization. And when it comes to personalization, what could be more personal than photographing your senior-portrait client in

As seen in the image on the facing page, with top-notch lighting skills, you can create professional-quality location portraits throughout the day—not just at the "golden hours."

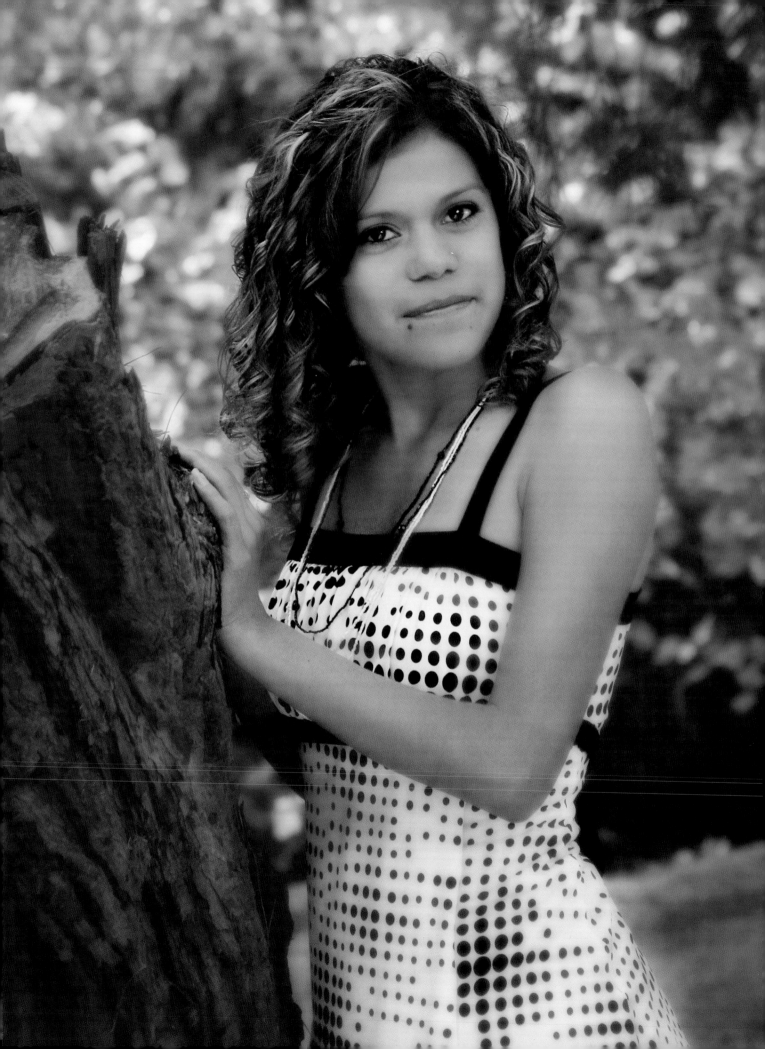

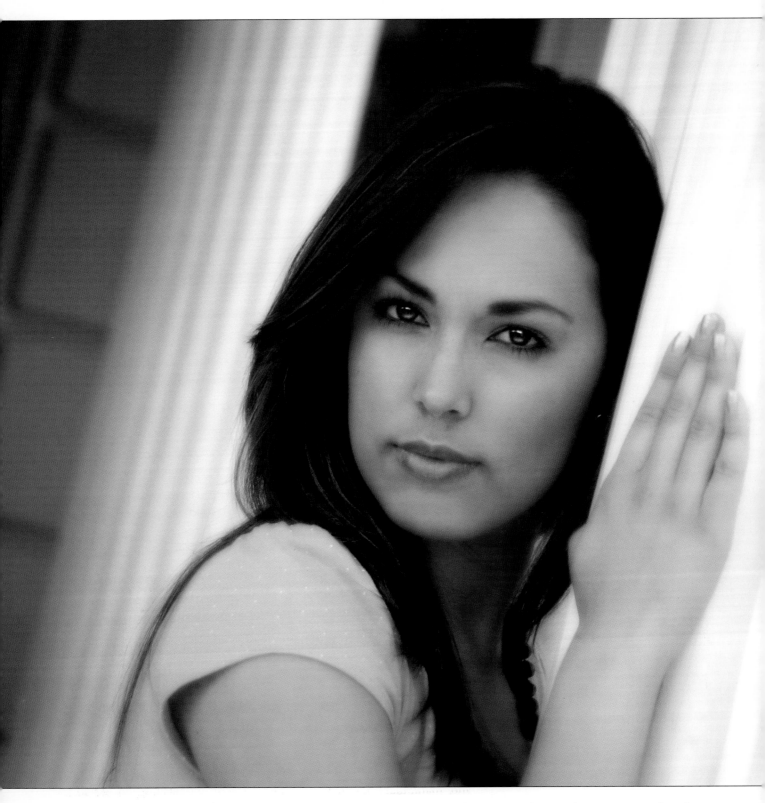

the bedroom that she has decorated with her favorite things, or in the home where she grew up? Surrounding the client (whether a senior, bride, family, or child) in an environment where they feel comfortable also produces a more relaxed experience during the shoot—and, typically, these portraits will actually generate a larger sale than a session done in the studio.

Architectural scenes are perfect for portraits with an elegant feel. Don't be afraid to try some variations. This location was also used with other poses to create the images on pages 19, 50, 109.

Increased Profits. While creativity is a good reason to go on location, a profit still has to be generated from each session to make it worthwhile. Travelling to and from locations can eat up a lot of a photographer's day. Therefore, many studios price location sessions so high that their average clients will not take advantage of them. This means that the client loses out on special portraits and you lose out on the additional profits they generate. In this scenario, no one wins.

If scheduled properly, however, location portraits can actually be *more* profitable than portraits shot in the studio. We set up our outdoor location sessions exclusively on certain days, then book an entire day of sessions at a single location. As a result, we can charge the same sitting fee as we do in the studio. This ensures that average clients will actually decide to do outdoor sessions—and remember, it's the sale of portraits, not the sitting fee, that brings in the real money. Using this strategy means that we maximize our profits from each session.

Our studio offers outdoor locations for spring and summer sessions, as well as indoor locations for winter sessions. We select some locations that are for casual portraits (typically park scenes), and some that are for more elegant styles of portraiture (typically upscale architectural scenes). If a client wants to go to their home or some other location that is special to them, we schedule these appointments before or after my studio sessions. This way, any driving I have to do is on my way in to the studio or on my way home. Naturally, the clients pay a higher sitting fee for the personalized location, which covers the additional driving, setup, etc.

■ LIGHTING: THE KEY TO SUCCESS

Now, you may have thought to yourself, "He shoots outdoors *all day?*" This *does* run contrary to the traditional teaching about natural-light portrait photography—but that traditional thinking makes profitable location photography almost impossible! We were all taught that the best outdoor light occurs right after sunrise and just before sunset. While this light is certainly ideal, it only lasts 30 to 45 minutes, which is barely enough time for one session. If you have to travel to the location, set up, shoot for only half an hour, then tear down, and drive home, you'll have to charge so much that very few clients will book these sessions.

Therefore, the key to success in location photography is learning to control and manipulate the natural light as it changes *throughout the day*. Whether you are a wedding photographer shooting an all-day event or a portrait photographer trying to work around the schedule of a busy family, sooner or later you will find yourself photographing outdoors at high noon and you had better know how to produce a professional-quality portrait using the existing light.

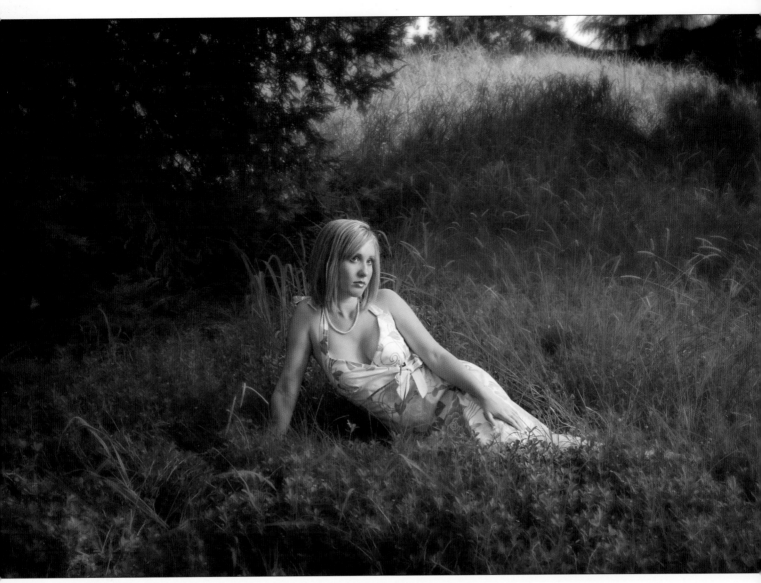

In this book we will discuss the many ways to handle lighting on location. Whether you are working at a park or inside a home you have many options when it comes to lighting a portrait—both naturally (using the light as it exists) and by modifying the existing light to make it look beautiful, yet natural. When you have mastered these techniques, you'll discover that shooting on location can be one of your most creative and profitable pursuits.

Location portraits typically result in a larger sale than a session done in the studio.

There are two strategies that photographers use on location. While both have the potential to produce some professional quality portraits, neither one provides the creative freedom or the efficiency required to sustain a profitable studio.

THE PROBLEM IS, THESE

PHOTOGRAPHS TEND TO

LOOK UNNATURAL . . .

The first strategy is to use only natural light, looking for the best light that a scene or location can provide and then working with it. Photographers who take this approach either take very few sessions (because they tend to work only at those few perfect times of the day when the lighting is ideal) or shoot images with little variety, because they are forced to use the same good locations over and over again. (On this point, think of the thousands of outdoor portraits you've probably seen with the subject leaning against a tree—one of the few safe spots if you rely on natural light during the midday hours).

The second approach is to modify the light, finding a scene and then adjusting the light to make that scene work. Photographers who use this approach tend to use flash or reflectors to overpower any natural light in order to achieve a consistent result. The problem is, these photographs tend to look unnatural and often lack the lighting qualities that should be evident in a professional portrait. You see this type of work from many wedding photographers who use their on-camera flash to eliminate the need to think during a hectic wedding.

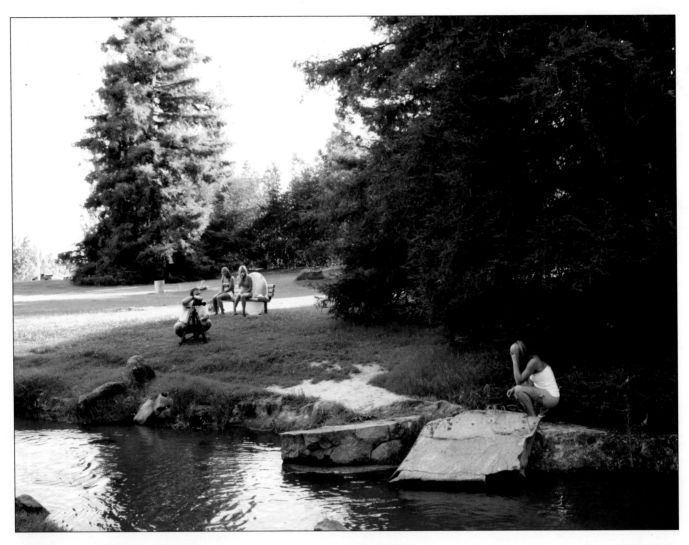

The light at the edge of an overhead obstruction is often good for portraits.

There are obvious problems to both approaches—and all of them stem from a failure to understand natural light and the best ways to control it. It's a problem I struggled with myself. When I first started photographing outdoors, I quickly realized that producing a professional-quality, salable image was much more difficult on location than inside the studio. Yet, when I tried to gain a better understanding of natural light, people seemed to explain the concepts in such vague terms that it really never helped me to achieve what I was looking for: lighting that would make my portraits look like those taken by the few photographers who really knew what they were doing on location.

My favorite term was the "quality of light." The truth is that light has no inherent "quality." It has direction and it has edge-transfer characteristics. The decisions you make regarding these factors will determine the look of the portrait—and whether or not your client will want to buy it. Just like the flash tube of a studio light, outdoor light has the "quality" that you give it by understanding how to manipulate it. Even direct sunlight will have a pleasing overall "quality" if you know what you are doing!

■ DIRECTION

The direction of light is a pretty easy thing to determine. As you approach a scene, stand where you plan to have your subject stand, then face toward the camera. If you see nothing behind the camera but blue sky, your lighting will have no direction. This would be the same as bouncing light off a plain white reflector above the camera in the studio; it's great for fill, but it's not a usable main-light source, because it lacks direction. In that same situation, let's say you turn around and you are facing a huge grove of trees or

The lighting in your location portraits should look just as good as the lighting in your studio portraits.

In this image, the direction of the light is obvious—it comes through the window from camera left. The light from the window is the highlight source, while the walls and ceiling of the room itself are the shadow source.

tall buildings blocking that blue sky from view. You still have no light direction, but you have found your source of shadow.

This is an important lesson that some photographers never learn: for light to have direction, there must be a light source and a shadow source. In the studio, you don't have to create a shadow; you're working in a dark room, so there's plenty of shadow. Instead, you need to fill the shadow. Outdoors, the opposite is usually true—the light source is too large and produces directionless, flat lighting. To create a shadow, we need to keep some of the main-light source from hitting the client by blocking it with a gobo. This is what gives the light some direction.

Now, let's go back to our example with a large expanse of blue sky in front of the subject and the huge grove of trees behind the subject. There is a rule that I heard many years ago—and it has always worked. The rule is to find

FOR LIGHT TO HAVE DIRECTION, THERE MUST BE LIGHT SOURCE AND A SHADOW SOURCE.

The directional light just under the edge of some overhanging branches makes this a good area for portrait lighting. However, there a lot of images taken with similar backgrounds, so try to spice yours up by refining the lighting with a reflector or using a more engaging pose than the average portrait.

the edge of the shadow, which would be at the edge of the large grove of trees where the blue sky begins. Then, turn the subject's body in toward the shadow (the grove of trees) and turn their face back toward the light (the blue sky). Follow this simple rule and your light will always have direction. While this is simple lighting setup, and one that can definitely be improved upon, it is a good starting place.

■ CONTRAST

The subject of highlights and shadows leads us naturally into a consideration of contrast. The first myth to get over is that in a portrait, our eyes are drawn to light. They are not; our eyes are drawn to *contrast*. If you put a white dot on a black page, your eyes will be drawn to the white dot; it is the area of greatest contrast. Reverse the scenario, making the page white and the dot black; again, your eyes will be draw to the dot. So is it the black dot or all the white that draws your attention? The answer is that it takes both to direct the eye.

Here, the contrast of the subject's lighter skin tone against the darker grass makes her stand out from the scene.

The transition zone of a portrait, the area from the darkest part of the shadow to the start of the highlights, is the key difference between an average photograph and a beautiful portrait. The wider the transition area, the more depth and realism your portraits will have. This is what separates outdoor snapshots from professional outdoor portraits that clients will actually buy.

The French doors to camera right (bottom) provide relatively hard lighting, forming bright highlights that transition quickly into dark shadows. The look this produces is quite dramatic (top).

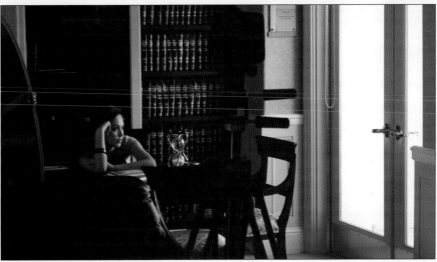

Open sky, a reflector, and white marble—there's light everywhere in this image! The result is a portrait with very soft lighting. The shadows are there, but they are very light—and the transition from highlight to shadow is very gradual.

Shadow, and the transition from highlight to shadow, has more to do with creating a professional quality portrait than light does. Controlling this transition area requires you to understand another characteristic of light: whether the effect a given source produces on your subject is hard or soft.

Imagine you are in the studio and use a white umbrella for your first few shots. Then, you switch to a silver umbrella of the same size as your main-light source for the subsequent shots. Both sources will provide usable light, but the characteristics will be different. Which umbrella to use will depend on the look you want to create.

The same is true with natural light sources; your main light will vary in size and intensity, and this will change the characteristics of the light produced. At a given intensity, the larger the light source, the softer the light will be; the smaller the light, the harder the light will appear.

Let's say you go into a client's home. There, you find many windows of different sizes and facing in different directions. For your first shot, you choose a very large, north-facing window for your main light. This source

SHADOW HAS MORE TO DO WITH CREATING A PROFESSIONAL PORTRAIT THAN LIGHT DOES.

would provide light with very soft characteristics. It would be perfect for a soft, dream-like photograph. The second location you choose in the house has a smaller north-facing window. Would that change the characteristics of the light? Of course it would. The third spot you choose is a very large window that faces a white wall that reflects sunlight back through the window. Again, the light's characteristics would change.

The same principles apply to lighting at a park. Light provided by a large area of open sky provides very soft lighting, similar to the large, north-facing window. If the scene has obstructions that reduce the size of the open sky relative to the subject—just like the smaller window—the light will have a harder characteristic. Finally, if you find a scene that has a main-light source where the sunlight reflects off a white wall, the characteristic will change again because of the intensity of that light.

The point, of course, is that *all* of these light sources would be usable to produce a salable portrait—provided you select the correct lighting for the look that you and your client want in the portraits. To determine this, you have to think about the final portrait and then work toward the envisioned end product.

To determine the best main light source, you have to think about the final portrait and then work toward the end product you have envisioned .

Light sources with harder characteristics provide good textural detail and create slimming shadows.

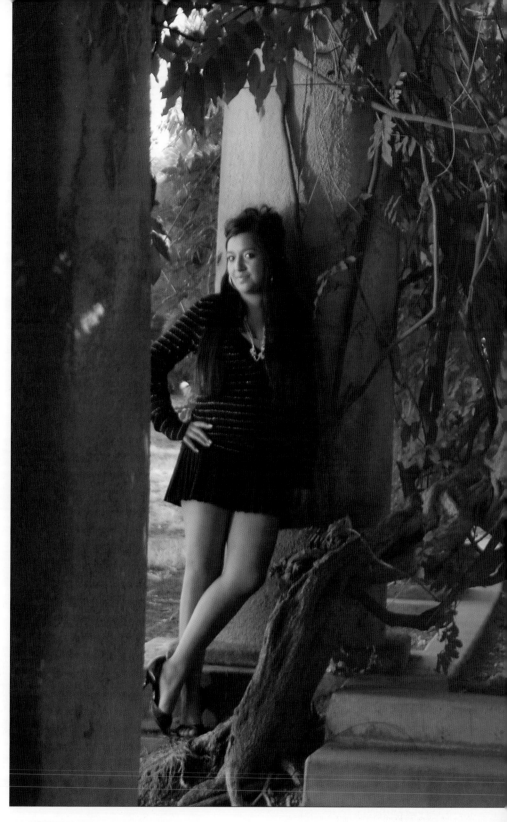

Imagine you are photographing a bride in her home or at an outdoor location. When most photographers think "bride," they also think "soft light." The problem with *really* soft light is that it doesn't bring out texture or detail. If the bride has selected a gown with beautiful lace and beading, she will be broken hearted if it doesn't show. The second problem with soft light is that it doesn't provide an adequate shadow for a full-length portrait

of an adult woman in a white dress. If you are a woman, married to a woman, or have read the statistics about how women feel about their bodies, you know that over 80 percent of women think they are overweight (and 99 percent think their hips and thighs are too large!).

In my book *Corrective Lighting, Posing & Retouching Techniques for Portrait Photographers* (Amherst Media, 2005), I talk in detail about how to make clients look their best. I don't want to rewrite that book here, but this is the basic idea: by posing and lighting an average client correctly, you can provide them with an image their ego can handle. When you do that, you end up selling the work you have created. The best way to make your bride look her slimmest is to use light that provides a larger shadow area. This means using a light source that has a harder characteristic. Such a source will bring out more detail in the lace and beading on her gown while providing a deep shadow to slim her waistline and hips.

Lighting that leaves part of the body in shadow creates an instant slimming effect.

catchlights

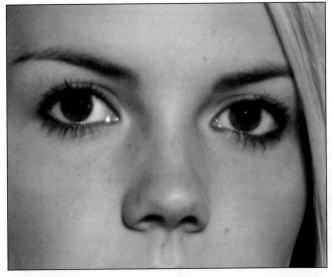

With no direction to the light, catchlights are absent and the eyes have a dull look.

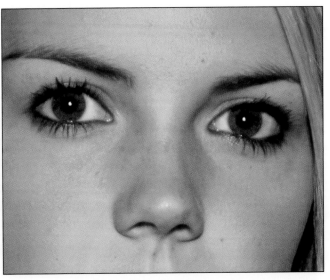

On-camera flash creates a tiny catchlight in the center of the eye. This is not the ideal position.

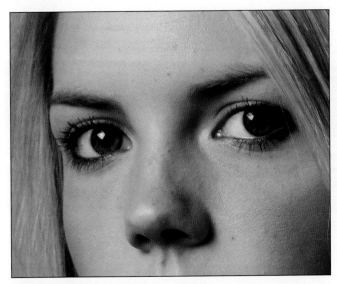

In this final image, the catchlights are strong, well defined, and located in the proper position on the eye. This is the result you want in a professional-quality portrait.

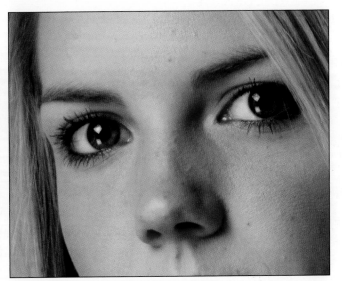

Here, the catchlights are in the proper position. However, a reflector used below the subject has produced an obvious secondary catchlight. This looks unnatural.

Although I rarely photograph brides, I often face this problem when photographing young ladies in beautiful gowns. In the studio, I tend to photograph these subjects using a small light box with a grid attachment to illuminate just the face, shoulders, and bodice of the dress. Then I add accent lights to highlight just the areas I want to see. Outdoors or on location, this same type of control is possible. We will talk about how to achieve this in an upcoming chapter.

■ CATCHLIGHTS

When it comes to finding the natural main-light source, my final suggestion is to look at the client's eyes. Whether I am working in the studio, outdoors,

or at another location, I study my client's eyes every time I change a pose. When I see strong, defined catchlights in the proper place (either the 11:00 o'clock or 1:00 o'clock position) in each of my subject's eyes, I know the light on the subject will be beautiful.

As you look at the eyes in the photos on the previous page, you will see that the catchlights look different with different main-light sources.

■ PRACTICE MAKES PERFECT

Being able to find a natural main-light source is the first step in creating beautiful, natural-looking portraits. As you go to outdoor areas, practice finding main-light sources and study the light and shadows in various scenes. While you are waiting for a subject to show up or change their clothing, use the time to study the natural lighting and the effects the different characteristics of light have on objects in the scene. Only when you can see the light, find its direction, and identify its characteristics can you begin to consistently create location portraiture that has the same lighting quality as portraits taken in the studio.

FINDING A NATURAL MAIN-LIGHT SOURCE IS THE FIRST STEP IN CREATING BEAUTIFUL PORTRAITS.

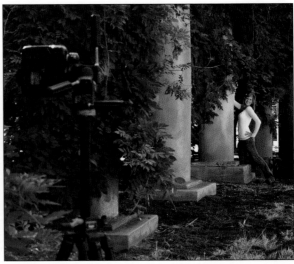

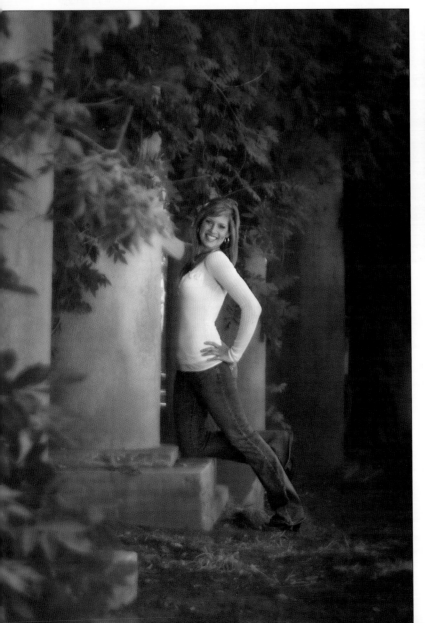

The natural light in this scene needed no modification. The covering of the columns blocked the overhead light, and the columns themselves provided shadow. Strong sunlight also reflected off the building and foliage, producing nice highlights. Everything was just about perfect! I like how the tones of the subject match the tones of the scene; the lighter-colored sweater is against a lighter area of the background, while the darker jeans are against a darker area.

Before we start into the techniques used for modifying and controlling lighting on location, there are some basic pieces of equipment and working techniques that will make your life on location a lot easier.

You'll notice that I don't mention any brands. Professional photography is about what you know, not the brand you use. Canon or Nikon, Mac or PC—it has nothing to do with the final product you show the client. If someone tells you differently, you can almost bet they are sponsored by the company whose equipment they are recommending.

PROFESSIONAL PHOTOGRAPHY
IS ABOUT WHAT YOU KNOW,
NOT THE BRAND YOU USE.

■ WORK WITH AN ASSISTANT

I always work with at least one assistant. In today's litigious society, I have a hard time believing that any photographer, man or woman, would feel safe going to a location and working alone with a client. This is just asking for trouble! My assistants are also critical when it comes to setting up and tearing down.

■ EQUIPMENT

When I go out for a full day of location shooting and have two assistants to help, I'll bring along the full range of equipment described below. If I go to a location for fewer sessions or only have one person helping me, however,

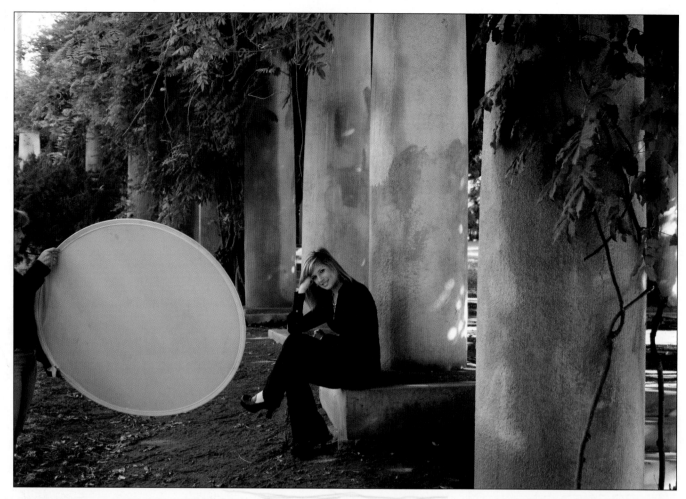

I narrow down the lighting equipment to the bare bones, bringing the core pieces of the studio lighting system and a few reflectors and black panels.

Tripod. On location, you often work with slower shutter speeds than you would in the studio, so it's important to ensure there is no camera movement. This makes having a heavy-duty tripod a must. The legs of your tripod also need to be easily adjustable, since you will often be working on terrain that is not level. I frequently find myself shooting from the bank of a creek or the side of a hill—places where the legs of my tripod are set at three different lengths to get the camera level.

Backup Gear. Since I go to outdoor locations that are a significant distance from my studio, I take at least one back-up piece of equipment for everything I will need. I also take many sets of charged batteries for the camera and to power my flash units. Additionally, I take at least two AC/DC converters to power my laptop for downloading images, and more memory cards than I will use. With digital, everything needs power, so packing properly becomes a must.

Lenses. On location, you will find that you will need a variety of focal lengths to get the shot you want. This means you'll need a selection of prime lenses or a zoom lens that covers a wide range of focal lengths.

Using an assistant is critical. Here, an assistant is seen holding a reflector to camera left. Additional examples of poses in this location appear on pages 79 and 119.

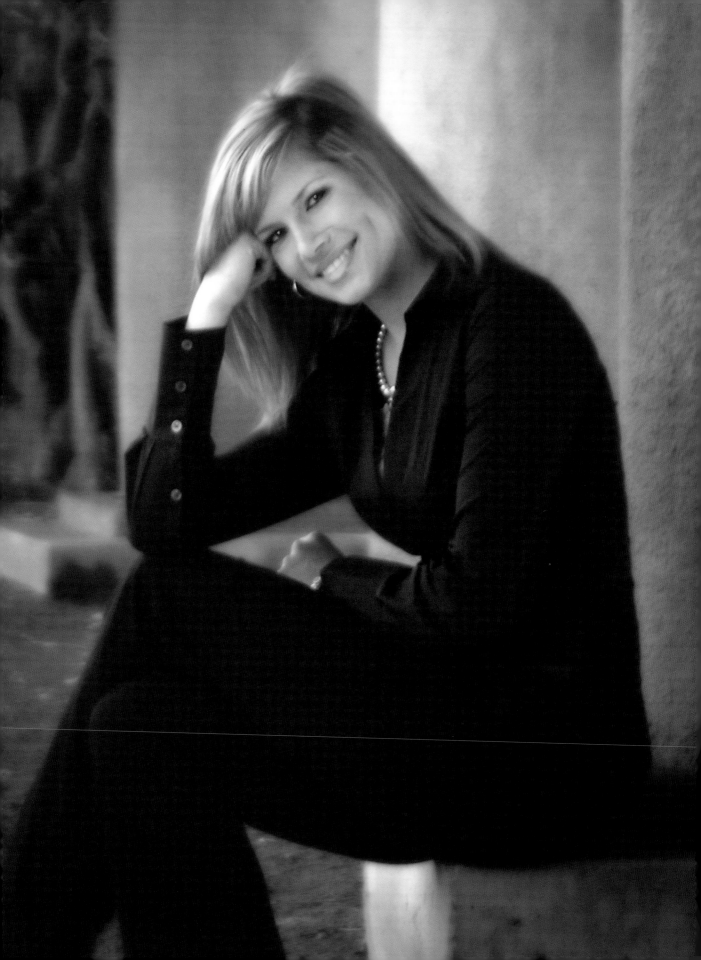

Imagine you are working in a home or outdoor location where you want to take a head-and-shoulders pose. While the background is usable, it's very distracting. One solution would be to pull the subject away from the background, throwing it further out of focus. In many situations, however, the room or setting won't physically allow that. In this case, the best solution would be to select a longer telephoto and open up to a larger aperture to soften the distracting background.

Sometimes, the lens can make the photo. Here, a fisheye lens was used to produce a distorted perspective. Keeping the subject near the center of the frame minimizes the distortion of her appearance.

You will also find yourself working in cramped situations where a wide-angle lens is the only choice that will enable you to get the shot you need.

The only focal length I *never* use is what is considered a "normal" lens for your format of camera (50mm for the 35mm format, 80mm for medium format, etc.). A normal lens gives you just that—a "normal" view of the world. Clients don't pay professional prices for a portrait that is normal in any way. Most of my portraits are taken using the traditional "portrait lens" focal length, 135–150mm for 35mm or 165–200mm for medium format.

Lighting Equipment. The lighting equipment I pack is much more than I actually need, but I use many different styles of lighting when I go on loca-

The subject's clothing has to make sense for a portrait to work. Here, the park setting calls for casual attire.

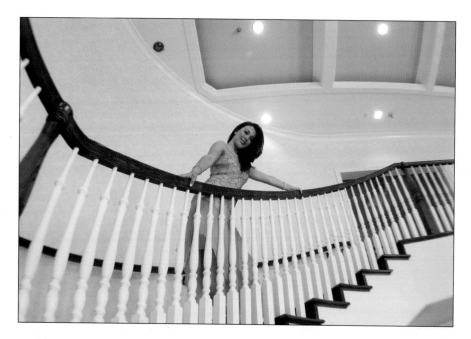

Whether shooting indoors or out, my goal is to include foreground elements that lead your eye to the subject and background elements that draw your eye deeper into the photo. In the image to the left, from the same series as the image seen on page 28, the railing leads your eye to the subject. In the image on the facing page, the out-of-focus pillars create a good sense of depth.

tion and I want to be prepared. I have a variety of white and silver reflectors in different sizes, many large black panels, and mirrors of different sizes. I also carry translucent panels, studio flash units, batteries for them, larger light modifiers for the flash units, wireless slaves, large light stands, weights, and grips.

Additional. In addition to the equipment listed above, we take a changing tent, plus a toolbox containing everything from sync adapters and cords (just in case the wireless goes out), to safety pins, tissue, and hair spray. If the weather is warmer, we also take an ice chest full of water for my staff and clients, who will get thirsty during the session.

■ BEFORE THE SESSION

Before the session, the client is provided with information to make sure that the choices she makes in preparing for the session will yield the style of portraits she wants. We give our clients the typical guidelines on what colors of clothing to avoid, the best styles of clothing for photography, and colors of clothing to wear in order to conceal problems such as wide hips and not-so-flat stomachs. A consultation DVD also explains makeup, jewelry, other accessories/props, and the coordination of clothing for portraits that involve more than one subject. Very little is left to chance in ensuring that every element of the portrait makes sense visually. After all, a beautiful image should be more than a shot in the dark.

■ BACKGROUND SELECTION

When I select a background, I am looking for much more than lighting and the basic coordination between the background and the client's clothing. I am looking at the overall feeling that a scene or backgrounds portrays, which

VERY LITTLE IS LEFT TO CHANCE IN ENSURING THE PORTRAIT MAKES SENSE VISUALLY.

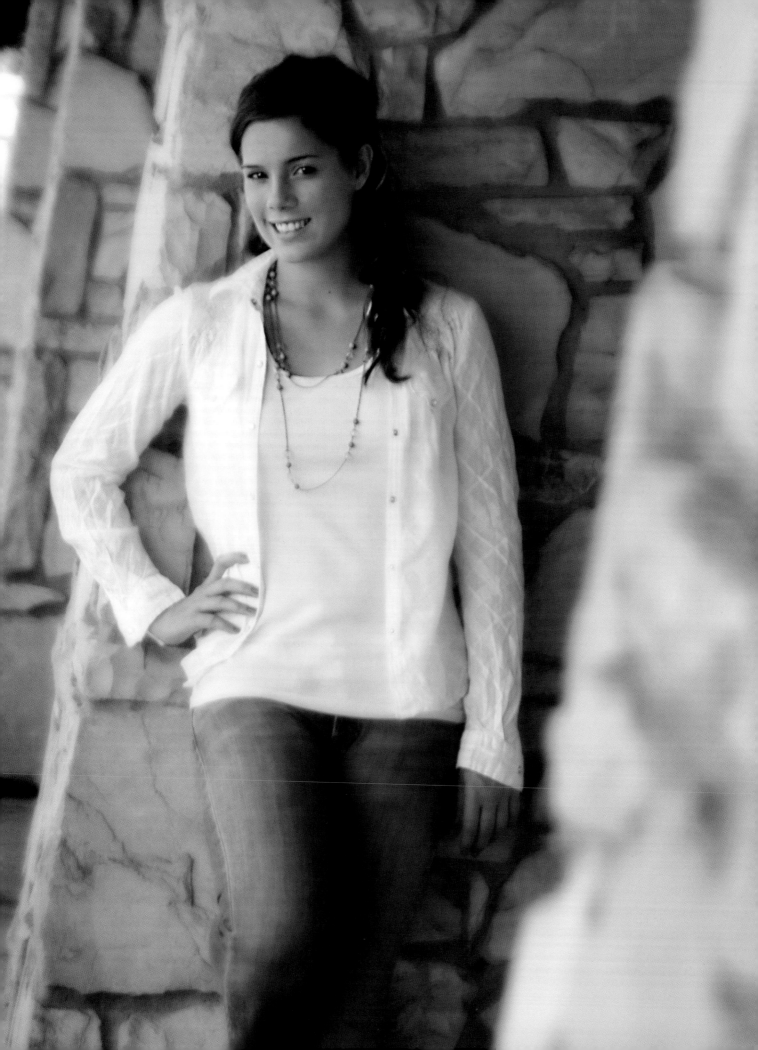

In addition to creating depth in a portrait, adding foreground obstructions allows you to conceal areas of your subject that they might not want to see in their portraits. For a simple variation on this pose, see the image on page 82.

is determined by the predominant lines and textures. Each line and each texture will affect the feeling the viewer gets when looking at the portrait.

I also look to give my portraits as much depth as possible. This is done by avoiding what most photographers do: placing the subject against a tree with a background a few feet behind them. If that's all you want, you could just as easily take the shot in or around your studio.

In most of my portraits, I want to have at least *two* points of focus in front of the subject and at least *three* points of focus behind the subject. Close-ups need fewer foreground and background points of focus, while a scenic full-length portrait may need more. My goal is to have foreground lead your eye to the subject and the background lead your eye further and further into the background.

There are two simple ways to increase depth in any portrait. Most photographers place the subject in a clearing with the background behind them.

I ALSO LOOK TO GIVE MY PORTRAITS AS MUCH DEPTH AS POSSIBLE.

Instead, I suggest putting the subject in the middle of the "background" area. This way, you have a foreground as well as background. A foreground is the missing element in most studio and outdoor portraits.

The second way to increase depth in a portrait is to look for a posing area that is at least twenty to thirty feet from the background. I often shoot from one grove of trees to another or find a patio, path, bridge, or fence/walkway to pose on. This puts more distance between the subject and the background. When there is nothing to use as a foreground at a greater distance, you can use a larger telephoto lens to throw the background further out of focus.

■ COMPOSING PORTRAITS

Photographers tend to like creating full-length portraits, and most of our senior portrait clients want to shoot these poses, too—they always want to show off their new outfit, shoes, painted toenails, or fit physique. However, the portraits that clients actually *purchase* are typically composed closer. If you remember that, you will always sell your work. Knowing that our clients reliably buy portraits that have a larger facial size than a full-length provides,

Shooting in the RAW mode gives you the most room for error—critical for shooting outdoors, where you simply don't have the precise control you may be used to in the studio.

we always take an additional close-up shot of every full-length pose. Since we started doing this, our sales have grown dramatically—and the number of people who want to "retake" poses or who have issues with the photographs from a session have been greatly reduced.

■ SHOOTING AND FILE MANAGEMENT

File Format. In the studio, I prefer to capture everything in the JPEG format for easy downloading and storage. Our clients preview their studio images immediately after the session, so this is the only format that works effectively.

On location, I shoot in the RAW mode. Shooting JPEGs requires strict controls over color balance and exposure. While this degree of control is possible in the studio, on location it would be impractical—the session would be more about exposure and control of color temperature than working with the subject. Shooting in the RAW mode gives us quite a lot of wiggle room in both exposure and color balance. When you are doing multiple sessions in an uncontrolled environment, this is critical.

After the camera is white balanced to the scene, we make a shot with the white/gray balance card in the frame.

White Balance. To ensure that all the images from a location session match, we create a custom white balance for each scene. This works better than using the automatic white balance. After the camera is white balanced to the scene, we make the first shot with a white/gray balance card in the frame. The white area ensures the image isn't overexposed; it would be immediately flagged in the viewfinder if it were. The gray area is a color-balance backup—should the custom white balance not eliminate any color cast, it's a quick task in post-production to balance the image to this neutral gray area (then apply the same conversion to the other images of the same scene).

File Management. I use a separate flash card for each session I photograph throughout the day. When I finish each session, my assistant takes the card to my truck and downloads the images onto the laptop, placing them in the client's folder. He or she then puts the card into the client envelope so the images are saved in two places for safe keeping. At the end of the day, the images from the laptop are downloaded to the studio's server and two DVDs are burned—one for the client file, and one as the daily backup file.

3. USING FLASH ON LOCATION

The major benefit of using flash outdoors is that it allows you to work with the natural light as it changes throughout the day. Instead of photographing two location sessions a day at the ideal times for natural lighting (just before sunrise and

just after sunset), you can work all day long. If you find yourself photographing a client at noon in a local park, you will enjoy the control and options that flash gives you. Instead of being forced to place yet another client under your favorite tree—the same one that probably appears in hundreds of your images—you'll have the ability to explore other locations and still produce professional-quality lighting.

Yet, flash is probably the most used and misused additive lighting source on location. So, let's start by looking at what *not* to do, then move on to explore productive techniques for location lighting with flash.

FLASH IS PROBABLY THE MOST USED AND MISUSED ADDITIVE LIGHTING SOURCE.

■ ON-CAMERA FLASH
When I go to public parks for outdoor portrait sessions, I see most photographers using their on-camera flashes and popping off shots one after another with no consideration for the direction and characteristics of the natural light. Their camera is set on TTL and away they go!

To all of you who think this is a viable option for creating professional-quality outdoor portraiture, I have a question. If I were to give you an on-

When using flash indoors, it's important to place the flash in a position that is in harmony with the room's natural lighting. Here, as seen in the image to the right, it's placed parallel with the large windows to camera right. Notice how natural the resulting light in the portrait on the facing page looks.

I HAVE NEVER SEEN

ANYONE ATTAIN SUCCESS

JUST BY DOING WHAT IS EASY.

camera flash and ask you to create a professional-quality portrait in the studio, what would you tell me? Most of you would probably explain that this is not a viable light source for producing a professional studio portrait—or that this light source is extremely limited when you compare it to all the options possible with professional studio flash units.

If on-camera flash wouldn't be your first choice in the studio, why should it be acceptable outdoors? In their defense, many photographers would say, "Because it's easy." That may be, but I have never seen *any* person in *any* profession attain success just by doing what is easy. You may be able to sell a 5x7-inch print in a wedding album with this kind of lighting—or perhaps a team/little-league shot—but portrait clients will not consistently buy this type of portrait from an outdoor session. They may come to you once, but any client who is looking for a professional-quality portrait, and who has the money to pay for it, knows the difference between a truly professional portrait and one that is not.

Since I wouldn't use on-camera flash as the main-light source in the studio, outdoors I use it only for an accent light if I need one in the scene.

■ STUDIO FLASH EQUIPMENT

When I use flash on location, I use Alien Bees studio lights (with a variety of light modifiers) powered by the Alien Bees battery. This is the first reference I have made to a specific brand of equipment, but I am so impressed with these lights that I wanted to share it with you—and, no, I don't get any free lights or financial compensation from Alien Bees! Alien Bees lights are lightweight, durable flash units that cost between $200 and $300 depend-

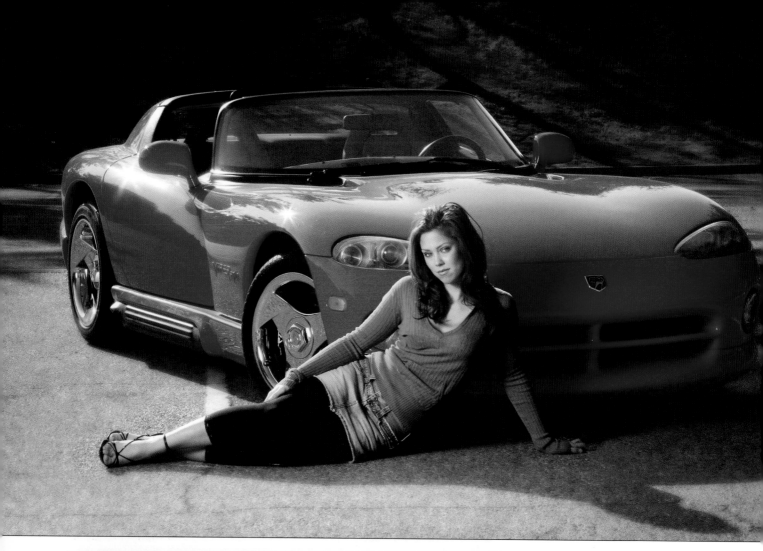

For most of my flash work outdoors, I use the Alien Bees Large Octagon Box, although I do have some smaller light boxes, as well as umbrellas for when they are needed.

ing on the light output. They have a line of accessories that are very modestly priced and all light box manufacturers (at least all that I have found) offer backplates to fit them. A flash tube for my Alien Bees costs about $30, as opposed to the $150 to $200 for the other brands of lights I use. Don't sell your current lighting equipment to buy Alien Bees, but when you are in the market for new lights, check them out.

Outdoors, I take the most powerful Alien Bees, which are approximately 600 Watt-seconds. I also use heavy-duty light stands weighted with sand bags or weights to keep the light from falling when the wind kicks up.

For most of my flash work outdoors, I use the Alien Bees Large Octagon Box, although I do have some smaller light boxes, as well as umbrellas for when they are needed. I really don't worry about the shape of a box or the corresponding shape of the catchlights in the eyes; with all other factors being equal, they all produce a similar characteristic of light. I should note, however, that I don't use rectangular boxes because I like my main-light flash to be far above the ground. I see many photographers whose images have bright foregrounds because they use large rectangular boxes and don't feather the light off the ground in front of the client. This gives the scene a very unnatural look.

■ **WHEN TO USE FLASH**

When doing head-and-shoulder poses, I tend to avoid flash. This is because the precision of your lighting is very noticeable in this type of image and the exact effects of your lighting from the flash are not visible until you take the picture.

Flash does, however, give you the greatest ability to balance the light in a larger scene, making it ideal for full-length poses. Another reason it works well in these longer poses is because any slight imperfections in your lighting won't be as noticeable.

■ **FLASH AS MAIN LIGHT**

Flash in an outdoor scene should only be used as a main light, not the fill light. Natural light is much too soft and delicate to try to fill the shadows with flash. Attempting to use flash for fill on location causes most of the unnatural lighting you see in outdoor portraits.

When we use flash outdoors, the flash is the main light and is placed in the main-light position (45 to 90 degrees from the camera position, at a starting height that has the light box roughly level with the subject's chest). The natural light is then used to fill the shadows.

NATURAL LIGHT IS MUCH TOO SOFT AND DELICATE TO TRY TO FILL THE SHADOWS WITH FLASH.

■ **FLASH CHARACTERISTICS**

To use flash outdoors, as in the studio, you must understand the characteristics of different types of light and learn how to control them.

With studio flash units, there are many factors that can impact the characteristics of the light: the size of the modifier, the interior fabric, the diffuser panels, whether the light reflects off the back of the light modifier or is aimed toward the subject, the use of louvers and grids, as well as the angle of main light to the subject. Here are some things to consider:

1. As noted in the previous chapter, the larger the light source, the softer the lighting.

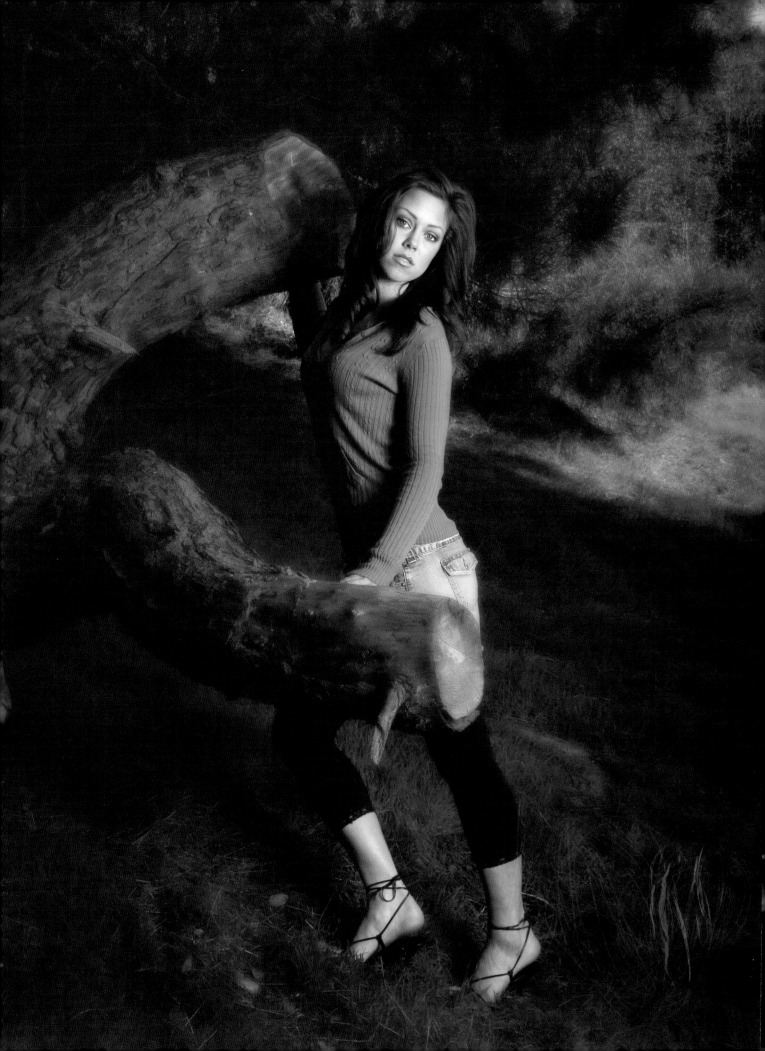

Here, the Octagon Box is used as the main light. A second softbox is added below the subject's head height to produce a more glamorous appearance.

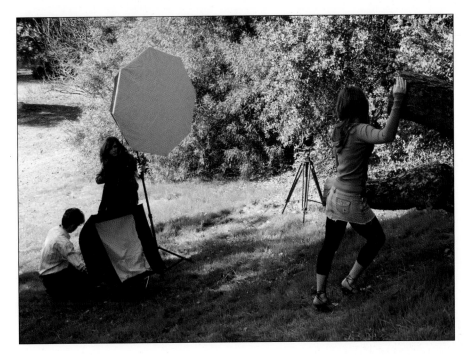

2. The closer the light source is to the subject, the softer the lighting will be.
3. A silver interior on a light box will provide more contrast than a white interior.
4. The opacity of the front diffusion panels will affect the characteristics of the light. I never use a second interior baffle because I feel this oversoftens the light.
5. Louvers and grids will increase the contrast of any light modifier and keep the light only where you want it in the scene.
6. The closer you place the light to a 90-degree angle to the subject, the more contrast the light will have. The closer you bring the light to the 45-degree position in relation to the subject, the softer the light will appear. It will produce less shadowing to contour the subject.

LOUVERS AND GRIDS WILL INCREASE THE CONTRAST OF ANY LIGHT MODIFIER.

This tells you how to control the lighting—and thus, how to control the outcome of the image. I am all about working with what I have to produce the look I want. You don't need every gadget known to man, you need to learn how to control light so well that you can reliably change its characteristics to produce exactly the look you want for a particular scene and/or client. For example, if you only had a 4x6-foot light box and you found the light it produced was too soft for a scene, you could:

1. Power up the light and move it further from the subject.
2. Take off the front diffusion panel.
3. Move the light more toward the 90-degree position.

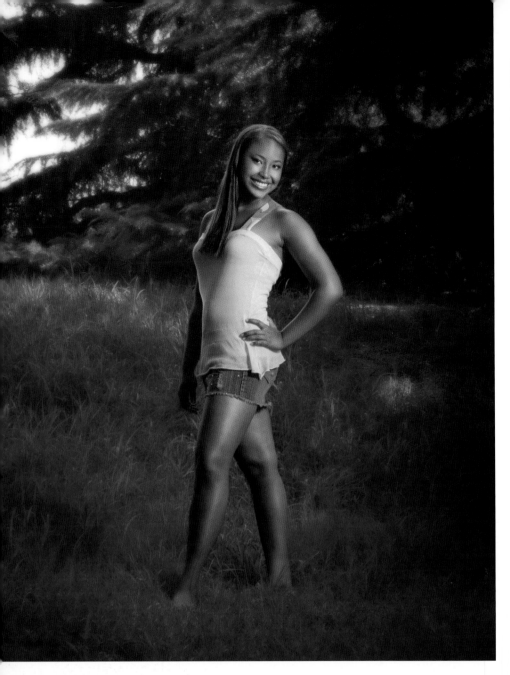

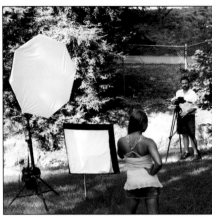

Here, you can see that the front panel of the flash, housed in a softbox, is on. This produces a softer light than removing the panel.

Knowledge is power—and when working on location you test your knowledge of lighting every day. Each scene, every room, or each side of a building will be different, and it's never controlled like in the studio. The creative process of working with flash on location is no different than in the studio. You first decide what you and the client want the end product to be, then you make the required decisions to lead you to that end product.

■ METERING

When shooting with flash, your shutter speed is limited by the maximum speed at which your camera will sync. This is typically between $\frac{1}{125}$ and $\frac{1}{500}$ second. Therefore, you only consider the measurement of the f-stop when setting the flash. The rendering of the natural/ambient light in your image will, however, be affected by both the shutter speed *and* the f-stop.

WHEN WORKING ON LOCATION, YOU TEST YOUR KNOWLEDGE OF LIGHTING EVERY DAY.

Let's say that we are working near your favorite tree in a shaded area that meters $\frac{1}{125}$ second at f/5.6. The background is two stops brighter—$\frac{1}{125}$ second at f/11. We set the main-light flash to give a reading that is $1\frac{1}{2}$ stops greater than the fill light source—f/8.5. This will give an overall lighting ratio of 3:1. (For a diffused image, you might want a 4:1 ratio, so you'd set the main light two stops over the fill-light [ambient] reading.) When all is said and done, then, in this lighting situation your fill light would be at f/5.6, your main light would be at f/8.5, and your background light would be at f/11. The half-stop difference between the main light and the background will be workable as long as the color of the background is relatively dark. If it were greenery, for example, you would be fine; if it were a white building, you would need to make some corrections.

To darken a bright background, you need to increase the amount of light on your subject. There are three limiting factors: the power of your lights, the maximum shutter speed at which your camera syncs with flash, and the amount of fill. Let's say you wanted to darken that white background in the above scenario. The background metered $\frac{1}{125}$ second at f/11, so to darken it in your image, you could set your main light to f/11, raise your fill to f/5.6.5 (to maintain the same light ratio on the subject), and adjust your

In this pair of images, you see the lighting setup (below) and final image (bottom). For this shot, the front panel was removed from the main light to create a harder lighting effect.

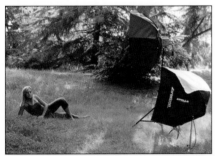

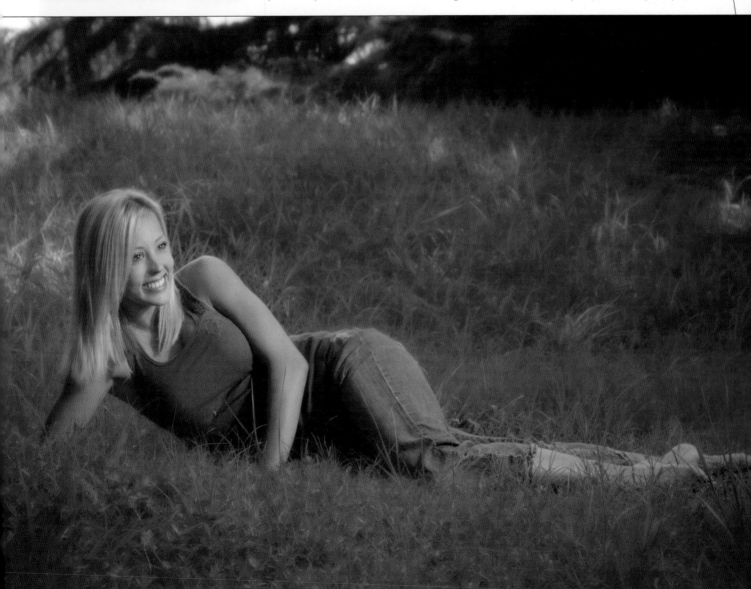

shutter speed to $\frac{1}{500}$ second. Your background would now be two stops darker than the main light on the subject.

But wait . . . if the fill source is the ambient light and it meters at f/5.6, how are we going to get it to f/5.6.5? Simple! We can use any additive light source. This could be a white or silver reflector that bounces light though a scrim, but an additional flash will give you the greatest ability to darken the background. This is because its effect is controlled solely by the f/stop, not the shutter speed.

The downside of using flash for both the fill and main light is that you have overpowered *all* of the natural light and changed the background. While this results in a scene that is controlled and usable, it can also look very unnatural if the effect is not properly metered and tested.

■ ADDITIONAL CHOICES

As we continue in this book, I will talk about the lighting choices I make in different types of locations and with different portrait styles. In all, flash is a viable option to help control all the variables in any given scene on location. While I don't use flash a majority of the time, because it is the least natural looking in the final portrait, flash can save your session in an otherwise unworkable situation and produce salable images for a client who has an inflexible schedule. Next, we will discuss my favorite additive light source on location: reflectors.

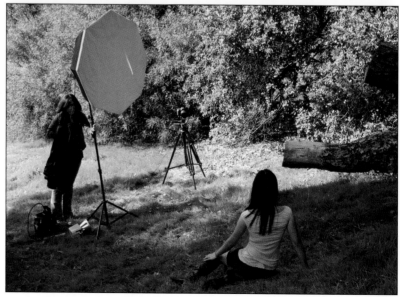

Flash in a outdoor scene should only be used as a main light, not the fill light. Here, the Octobox illuminates the subject to help balance her with the much brighter background.

4. USING REFLECTORS ON LOCATION

Reflectors come in all shapes, sizes, and surfaces, but the operating principle is the same: they reflect light from its source to where you need it in a scene. About half of the images in this book were taken using reflectors exclusively.

I HAVE A VARIETY OF REFLECTORS, BOTH RIGID AND COLLAPSIBLE, AND RANGING IN SIZE.

■ TYPES OF REFLECTORS

A reflector can be anything from a piece of foam-core board with duct-taped edges, to a PVC-pipe frame with fabric stretched over it, to any of the commercially manufactured reflectors—and everyone has their own opinion as to which is best. Photographers who like the rigid frames say that, with a few stakes, they can work in the wind; photographers who like the soft reflectors argue that when their reflector blows away, they aren't going to harpoon the girl down the beach. The choice and the risk are yours! Again, the most important thing is learning to use what you already own, not buying a whole bunch of new equipment.

My most-used reflector is a 42-inch white/silver collapsible disk. It is lightweight, easy to use with one hand (while I am photographing with the other!), and a great size for when you are working closer to the subject. I have a variety of reflectors, both rigid and collapsible, ranging in size from 16 inches to over 6 feet. The finishes range from white, to silver, to highly reflective silver—almost a mirrored finish.

While reflectors work well for me, they may not be ideal for every photographer. I work with assistants who can hang on to the reflector when a

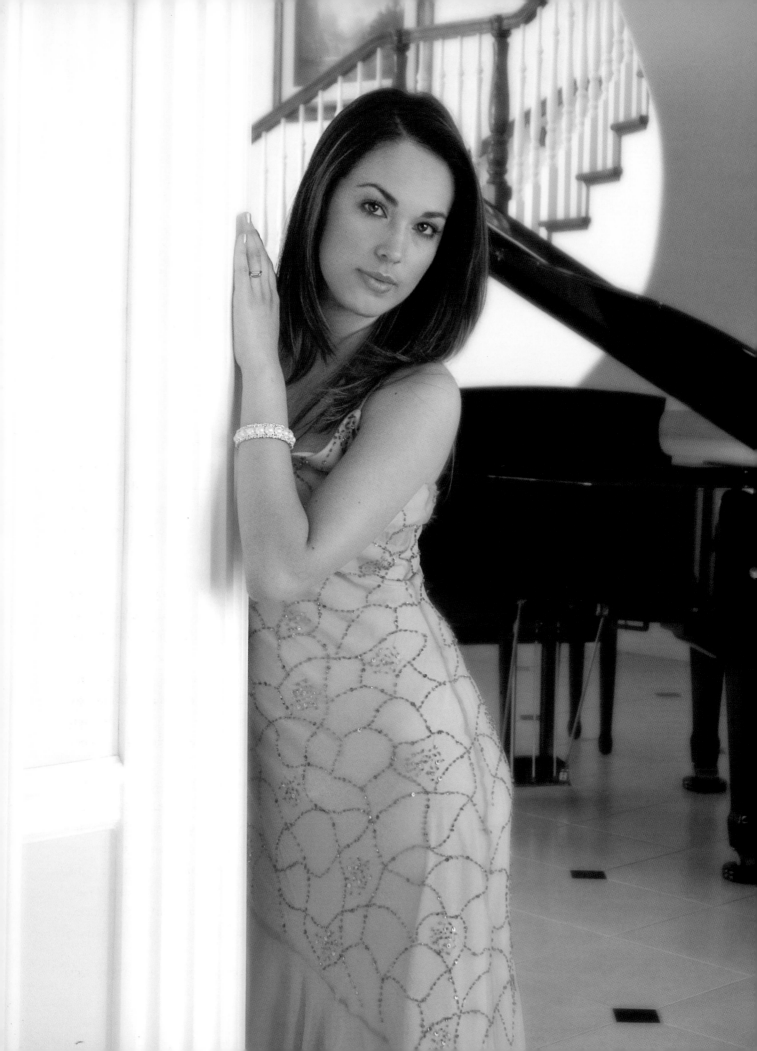

Reflectors of various sizes can be extremely useful for modifying the existing light on location shoots. Here, a very large reflector is used for fill, bouncing light from the French doors onto the shadow side of the subject.

breeze comes up—without their help, many of my reflectors would have been washed out to sea.

■ SIZE AND SURFACE MATERIAL

Size. Just as, in the studio, we select a main-light modifier based on the characteristic of the light it will produce, so do we select the size and surface material of a reflector based on the results we want. The size of the reflector controls the amount of light that it can produce and how broad an area it will cover. A larger reflector, just like a larger softbox, will produce softer light and larger catchlights in the eyes; a smaller reflector will produce more contrasty light and smaller catchlights.

Surface Material. The surface material is selected more by the volume of light needed than its characteristics. While light reflected from a silver reflector will have more contrast than light from a white reflector, it is usually the *amount* of light you need that makes you choose one over the other.

I typically use white to reflect sunlight and silver to reflect the light from the open sky when I am working in a shaded area and dealing with mostly natural light. Reflecting light from the open sky with a white reflector often doesn't provide enough light; reflecting direct sunlight with a silver reflector will definitely hurt your subject's eyes.

If you are going to use sunlight from a silver reflector, you need to learn how to feather the light. This means directing the main beam of the light away from the target area and using just the edge of the light, which is softer and less intense. In the case of using a silver reflector, you direct the main beam of light over the head of the subject and then slowly lower the light beam until you have the light intensity and characteristic you want. Make sure this main beam of light is out of the field of view of your camera. Otherwise, it will make a major hot spot in the scene.

REFLECTING DIRECT SUNLIGHT WITH A SILVER REFLECTOR WILL HURT YOUR SUBJECT'S EYES.

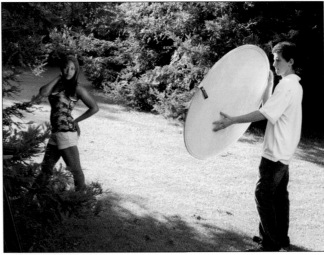

The silver side of a reflector is used as a crisp main light, bouncing light from behind the subject back onto her face.

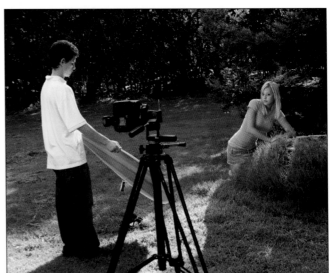

The sunlight from overhead is blocked by the tree branches, and a white reflector is used to bounce light back onto the subject's face for a soft lighting effect.

■ WORKING WITH REFLECTORS

While reflectors work well for adding light to a scene, they work best when you are dealing primarily with the natural light and modifying it. When you need to overwhelm the natural light to make a scene usable, flash is your best bet (for more on this, see chapter 3).

The best part about working with reflectors is that—unlike with flash—you see the exact effect of your lighting on the subject's face. That is why I choose reflectors whenever I am working with a subject for photographs

that will be composed from the waist up (i.e., not full length). In this type of pose, your lighting on the face is critical, so you must see the effects of everything that brings light to the subject.

I use reflectors to strengthen the catchlights in the eyes when I am working in natural light. I also place a reflector underneath the subject to add a more glamorous look to the lighting. I may also place one or two reflectors if I need to add accent light to an area of the subject I want the eye to be drawn to. In addition, reflectors work well as a fill source for the natural light provided by a scene and can brighten a too-dark background, providing separation for a client with darker hair and/or clothing.

When using a reflector you must first find the natural main-light source and determine its characteristic and direction. Then, you determine whether

If you are going to use sunlight from a silver reflector, you need to learn how to feather the light. This means directing the main beam of the light away from the target area and using just the edge of the light, which is softer and less intense.

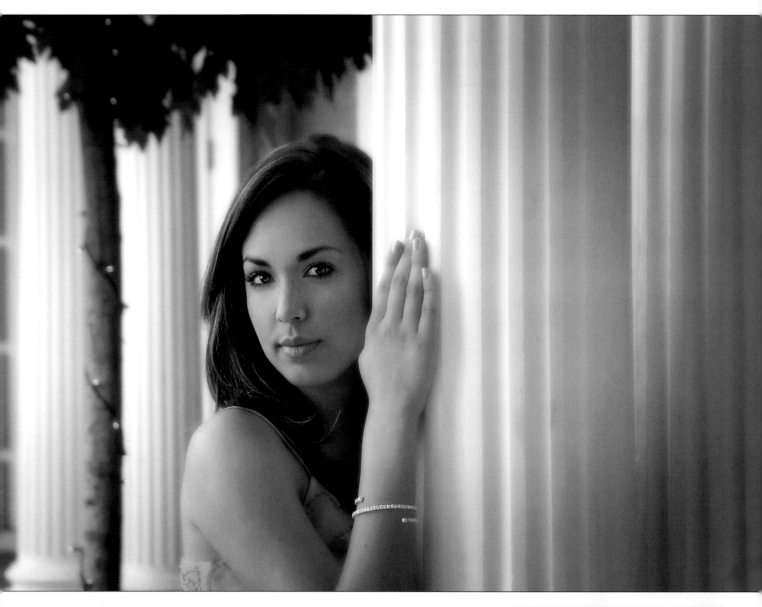

A big advantage of using reflectors is that, unlike with flash, you can instantly see the results you are achieving.

the main-light source produces the look you want while producing beautiful catchlights in the eyes. You might like the look of the light, but find that the catchlights seem a little weak. In this case, a reflector on the main-light side can brighten and define the catchlights without destroying the natural light.

Maybe the natural main source is sunlight being reflected off a white building. It provides beautiful illumination, but the shadows are too deep to provide a good transition zone. Here, a large white reflector on the shadow side of the subject can fill the shadow and save the shot.

If your main-light source is too large and lacks direction (and you don't want to get into subtractive lighting techniques; see chapter 6), you can overpower the natural main light with reflected light.

5. USING MIRRORS AND FLASHLIGHTS

Two useful additive light sources for location photography can be found at a home store. Mirrors and high-powered flashlights can add light to a subject or scene when reflectors and flash are not possible or won't produce a natural look.

THIS TECHNIQUE IS USEFUL
WHEN YOU WANT
TO ADD A MAIN SOURCE.

■ **MIRRORS**

Mirrors can be used alone as accents, for separation lighting, or to raise the overall illumination of an interior by directing sunlight through a window or doorway and letting it bounce off a ceiling or wall. Many times, small hand mirrors can add just the right amount of light for an accent on the hair or another part of the subject. As with any other light source, the size of the mirror will change the characteristics of the light source.

With Scrims. A scrim is a piece of translucent fabric that softens the light as it passes through it. I've included them in this section because when I use them, it's typically with a mirror. The mirror is used to redirect the sunlight to an appropriate position for a main-light source, then the scrim is used to soften the light.

This technique is useful when you want to brighten a scene by adding a main source, but when you also want control over the exact effect of that source. Just like reflectors, with a scrim and mirror, what you see is what you get. Unlike reflectors, however, this techniques allows you to bring a very bright daylight source down to a usable level—without burning the subject's eyes or getting shiny skin.

To use light from the doorway deeper in the home, a mirror was placed in the front yard and directed through the doorway to reflect light off the ceiling.

While using mirrored light and a scrim is more cumbersome than using a reflector, the light that it produces is much more controllable. Reflectors must be twisted and angled to get the needed light into the correct area—and many times the position you need to place the reflector in to get the light just right is less than ideal.

Another benefit of using mirrored light and a scrim is the control you have over the size and characteristics of the light. With reflectors, the size of the reflector does effect the size of the beam of light it provides, but it isn't all that controllable. With a variety of mirror sizes and the ability to put mul-

REFLECTORS MUST BE TWISTED AND ANGLED TO GET THE LIGHT INTO THE CORRECT AREA.

tiple diffusion panels on the same frame, much more control of the light is possible, while still providing a natural-looking light source (unlike flash).

I typically use a larger mirror, approximately 24x30 inches, for the main-light source and use a smaller 11x14-inch mirror for a lower light from under the subject. Since I have assistants, I have them position the mirrors to the correct height and angle. Currently, we use old glass mirrors left over from when we remodeled. If I were to buy them today, I would use Plexiglas mirrors to save on weight.

When I use scrims, I typically use a rigid-frame fabric panel. With two of these panels clipped together to form an A-frame, the scrim is free standing.

Two mirrors are directed through a scrim (above) to create the main-light source for the final portrait (right).

This also gives me more control over the natural light, since the second panel is available to add black fabric or another scrim, depending on how the light needs to be modified.

■ FLASHLIGHTS

Another unusual, but very effective light source is a flashlight sold at any home or hardware store. Flashlights have changed dramatically over the years. Now they have flashlights that are more powerful than many of the lights in your home.

Many seniors like the wall texture and décor in one of our front waiting areas of our studio. There is no room to set up flash, and the natural light from the window isn't in the correct place—plus we have to work fast, for obvious reasons. With a blue gel over the flashlight, it produces workable flesh tones, however the light is a spot and very harsh, so we use some diffusion material to soften it and make the light workable.

A Rosco 3202 blue filter is needed to correct the color of the flashlight.

The only problem with this light is that it obviously isn't color balanced for daylight. Therefore, a Rosco 3202 blue filter is needed to correct the color of the light. Light from a flashlight provides a spotlight quality, which is nice if that is the look you want. The light can also be diffused, however, by placing translucent material over it. The amount of light from a flashlight is not adjustable, so I purchase a very powerful light and use neutral-density filters over the light to reduce its output as needed.

Flashlights are also useful for adding light in tight places where reflectors or mirrors won't fit and flash would be too intense.

■ USING TOOLS WISELY

Mirrors and flashlights are tools, just like reflectors or flash, that should be used when they are most suited. If you are in a park scene and the subject needs additional light added to a particular area, a flashlight wouldn't be the best choice; it is the least controllable option and the hardest one to work with. If, however, you are in a small area between two buildings, with no room for flash and no light direction for mirrors or reflectors, the flashlight would be necessary.

I NEED TO BE ABLE TO COME UP WITH A SALABLE PORTRAIT NO MATTER WHAT A SCENE THROWS AT ME

While every photographer has their opinions and favorite tools, I like to have all the tools necessary to create a salable portrait in any situation. Some of these tools will not be used in every session, but they are always available when they are needed. While some photographers might consider this overkill, as a professional who wants to live well, I need to be able to come up with a salable portrait no matter what a scene or location throws at me.

Up to now we have discussed ways to add light to a scene, or to balance it, to achieve the look we want. Now we are going to start talking about taking light away from specific areas of a scene to improve the quality of your portraits. This is known as subtractive lighting.

6. SUBTRACTIVE LIGHTING OUTDOORS

Subtractive lighting is just what the names implies: removing light or, in essence, creating shadows to achieve a more dimensional portrait. I learned subtractive lighting from Leon Kennamar, who was probably the most well-known subtractive-

light photographer of his day. The outdoor portraiture he created was truly outstanding, because with subtractive lighting he could completely control the shadows of his images—something that most photographers to this day don't do. As we have already learned, it is the darkness that draws our eyes

Here, a reflector is actually used as a gobo. Placed directly over the subject's head, the reflector blocks the overhead light and eliminates the dark circles under the subject's eyes.

A white reflector is used over the subject's head as a gobo, blocking the overhead light and producing a more flattering lighting effect.

to the light and without shadows, no one notices or cares about the light. The downside of the teaching of subtractive lighting is that, while it is great for creating shadows, reducing the size of the main light to a proper size, or keeping light from hitting a certain part of the subject or scene, a scene must be close to ideal to use only subtractive lighting techniques.

To demystify subtractive lighting, let's call it what it is: creating shadows. For example, if you have a main light that produces beautiful catchlights in the eyes but a flat lighting on the face, you know that your main-light source lacks direction and is too large. To correct the problem, just put a black panel, gobo, flag, or other light-blocking device on the side of the subject where the shadow should be. This will create a shadow and improve your final image.

Which type of light blocker to use will depend on the circumstances. Black devices block light from the desired area, but they also tend to suck the light out of neighboring areas. Depending on the light levels and scene, white blockers can actually bounce light back onto your subject, adding a color cast or changing the desired appearance of the lighting. Let's imagine you are placing a blocker above a subject to block the overhead light. If my subject was standing in a grassy area, I would typically use a white reflector for this. The light from the ground won't cast enough light into this white reflector to act as a light source and won't affect the light hitting the face. If, on the other hand, the subject was standing on light-colored concrete in direct sunlight, the concrete would reflect up enough light to change the appearance of the lighting. Switching to a black device might be necessary, although it would tend to darken the hair of the top of the head.

■ BASIC DECISIONS

The decision to add light or take it away always starts with the selection of the background. Many photographers suggest that you first find the light and then determine the background based on that area of ideal lighting. This is the practice employed by photographers who work at those "ideal light" times of day. When I go into an area, however, it is usually in the middle of the day, so my first consideration is to look for usable backgrounds; I know that I can make the light usable no matter what it currently looks like. This is the basic idea of working on location when the lighting isn't perfect—it is much easier to change the light on the subject than the light on the background or the scene around the subject.

Once a background is located, the next decision is whether to use additive light sources or subtractive light sources—although there are times that both are used in the same image. This is typically a straightforward decision: if the light on the background is more intense than that on the subject, you *must* use at least some additive light sources. However, if the background is

THE DECISION TO ADD LIGHT OR TAKE IT AWAY STARTS WITH THE SELECTION OF THE BACKGROUND.

The unmodified light gives this subject raccoon eyes and unpleasant highlights on her cheeks and nose.

Adding a gobo overhead corrects some of the problems, but leaves the image without any shadowing to shape the face.

Placing a black panel to camera right creates a shadow zone.

BECAUSE THE LIGHT IS COMING FROM DIRECTLY OVERHEAD, THE SUBJECT HAS RACCOON EYES.

lit by the same light as the subject, then subtractive lighting alone may be enough. I find that there are very few scenes in which the light can't be improved dramatically using additive or subtractive techniques.

■ **SUBTRACTIVE LIGHTING IN PRACTICE**
The easiest way to learn subtractive lighting is to start with a subject and available light only. Then, add the lighting controls you need and observe their effects as you transform the portrait into a salable image.

In the first image (above left), you see this beautiful young lady in a typical outdoor location. The amount of light in the subject's area is relatively close to the amount of light on the background area. This means that we will not have to add light to balance the scene (i.e., darken the background). However, because the light is coming down from directly overhead, the subject has raccoon eyes as well as unattractive highlights on her forehead and nose.

The first correction I would make is to place a white reflector overhead to block this light. I would use white here because the shaded grass will not reflect enough light up to the white reflector to affect the final image. In the second photo (above center), you can see the improvement in the lighting with just that one correction. Yet, while the image is improved, there are still some problems that need to be corrected. The eyes have nice catchlights in them, but the face has no shadowing or transition zone to draw the viewer's eyes to the most important areas of the face and hide those that shouldn't be seen.

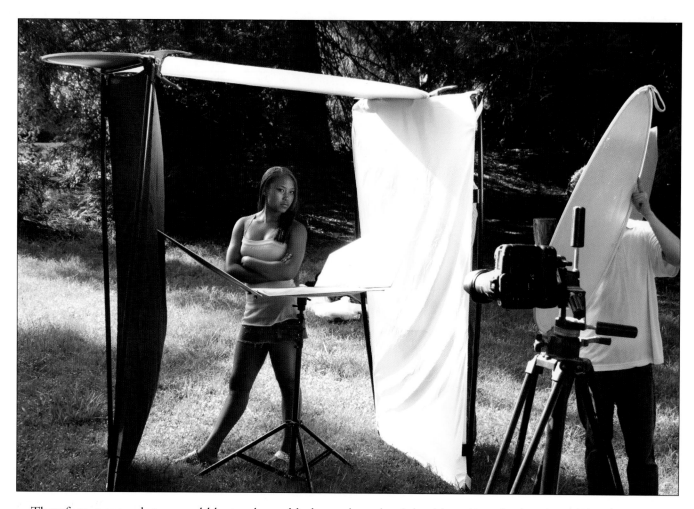

Therefore, a second step would be to place a black panel on the right side of the frame to establish a shadow zone and create a transition from highlight to shadow. In the third image (previous page, top right) you see the effects of this change. The face appears thinner and the structure of the face is more noticeable. While this is a major improvement, we aren't done yet!

As you look at photo three, you see a little highlight toward the end of the nose, this means that the main light is wrapping too far around the subject. To compensate, you could put another black panel on the opposite side of the subject to reduce this side light—but that would create a second shadow on the highlight side of the face. The best solution is to use a piece of translucent fabric. Placed to camera left, this will reduce the light coming from the side without creating a second noticeable shadow area.

Now we are getting close to a salable image—actually, at this point, this image is better than most of the outdoor portraits I see displayed in some studios. Still, let's take it one step further. Since most of the light in this scene comes from above, I almost always add a white or silver reflector underneath the subject's face to give the portrait a more glamorous look. The light from this reflector brings out more of the eye color; softens the darkness under the eyes, something all of us have; and helps to smooth the

Using the photo booth (above) makes it easy to deal with outdoor light and create a beautifully lit head-and-shoulders portrait (facing page).

I ALMOST ALWAYS ADD A WHITE OR SILVER REFLECTOR UNDER THE SUBJECT'S FACE.

complexion. I use white when reflecting sunlight and silver when reflecting light from a shaded area. At this point we have created a salable professional portrait.

Subtractive Light Photo Booth. Subtractive lighting is one of the simplest ways to control the lighting in an average scene. Therefore, I have used these principles to assemble a photo booth that provides perfect outdoor lighting with any outdoor background. This booth consists of the exact combination of modifiers discussed above: a 4x8-foot black panel on a rigid frame, a translucent panel on a rigid frame, a white reflector attached to the two panels with clamps, and a white or silver reflector clamped at the level needed to provide light in the appropriate place for a head-and-shoulders pose.

This photo booth makes outdoor lighting very easy to deal with. To use it, I look for an area that has strong backlighting, usually provided by the sun. I want to have each client separated by a backlight, since the majority of them have darker hair and I instruct them to wear darker shades of clothing as well. When I can find this backlight, I use the white reflector; when working in a shaded area with little or no backlight, I use the silver reflector.

The only variable in this setup is the main light. In most scenes, the area in front of the subject will be open sky, providing a fairly good main-light source—at least with all the photo-booth's modifiers in place. Should the area have obstructions that don't provide a usable main-light source, you can simply add a reflector or scrim with mirrored light to produce one.

Now that we have talked about the basic principles of lighting I use, the next step is to look at a variety of locations and see the choices available when dealing with what we find there.

7. HEAD-AND-SHOULDERS ON LOCATION

One of the best ways to teach you how to create beautiful images on location is to take you to various outdoor locations and show you the steps I took to create the images you see in this book. The first situation we are going to work with is a

head-and-shoulders pose in a park setting. Then we'll move on to create a portrait at a senior's home.

■ PARK SETTING

Basic Setup. For this session in a park, I selected a scene that had potential as far as the lighting and background are concerned. Still, it needs some work to create a professional-quality portrait.

This picnic area is covered with large stone columns that will be good in the foreground, and it is far enough away from the greenery in the background to add depth. In the first overview photograph (facing page, bottom left), you see the natural lighting as it exists. The light from directly overhead is blocked by the patio roof.

The next step is to consider the main light. This light has direction, as you can see in the first image of the subject on the facing page (top left). However, it is not as bright as the light on the background, so if no light is added to the subject, the background will appear lighter in the portrait than it does to your eye. At this point, you have a decision to make: do you add light to create a main-light source, or do you let the background step up to

THIS SCENE NEEDS SOME WORK TO CREATE A PROFESSIONAL-QUALITY PORTRAIT.

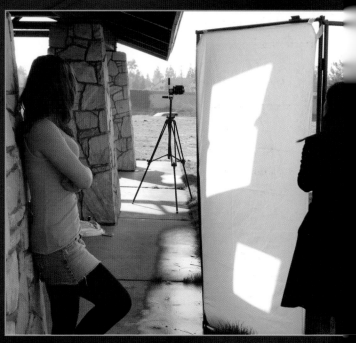

This overview of the scene (left) shows the light as it naturally exists. In this lighting, the subject does not look her best (top left). To improve the lighting, a scrim was added (above). Two mirrors were then placed to bounce light through the mirror and through the scrim. The final effect (top right) is much more appealing.

a higher key? I prefer to have the background record darker—the way it appears in the actual scene.

With that in mind, I know I will have to add light to the scene to balance the light intensity between the subject and the background. This image is going to be closer up (not a full-length portrait), so flash wouldn't be an option. Therefore, I decided to use a scrim with mirrored light to give me precise control of the final image. With the scrim about four feet away from the subject, my assistant held a 24x30-inch mirror in the main light position. A 16x20-inch mirror reflected a second beam of light lower on the scrim to replace the silver/white reflector that I typically put below the subject's face. This setup is shown in the bottom right photo on the previous page.

In the final photo (previous page, top right), you see that the mirrored scrim light produces a beautiful effect. At this point, we have created a salable portrait—but it could still be improved. The column and patio roof have not allowed much light to illuminate this girl's beautiful hair. Adding a silver reflector to the side of the young lady would give her hair a more lustrous look.

Variations. Once my primary shot has been captured, I often rotate around the client to find another background. In the images here and on the facing page,

A black panel is added to camera left to produce a shadow area (left). Light is also added below the subject using a reflector (below). Finally, a mirror is placed to camera right to add highlights on the subject's dark hair (bottom).

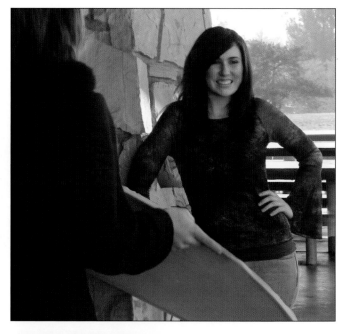

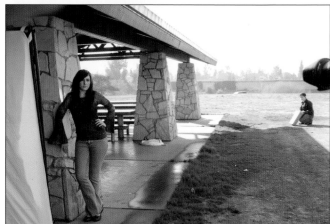

The final portrait is a beautiful, salable image that makes the client look her best.

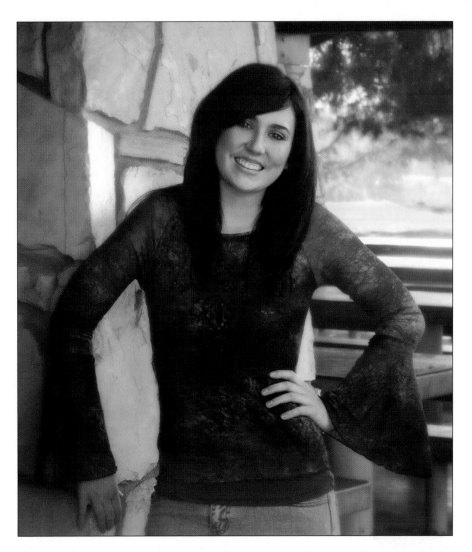

BACKYARDS FREQUENTLY HAVE
MAIN-LIGHT SOURCES OF
QUESTIONABLE QUALITY

the subject is at the edge of the column, so the light coming through the patio cover to camera left has eliminated our shadow. Therefore, a black panel needs to be placed to block the light (i.e., produce the shadow). This is seen in the left photo on the facing page. At this point, the natural light is a usuable main-light source.

To finish off the look of the facial lighting, I add my light, here provided by a reflector, coming from beneath the subject (facing page, top right). Since I am using light from a shaded area in this portrait, I use the silver side of the reflector.

To finish the lighting, I have my assstant place a mirror in the sunlit area to reflect back light onto the subject's hair, since it is so dark (facing page, bottom right). Once again, this portrait is a beautiful, salable image that makes the client look her best.

Most head-and-shoulders poses taken at outdoor locations will present you with similar challenges. Outdoor courtyards, patios, large parks, or backyards frequently have main-light sources of questionable quality—often either *lacking* direction or having *too much* direction. Lighting at typical out-

door locations is more about overcoming problems than finding ideal light. If you rely on ideal lighting, you will find yourself working only two hours a day, or exclusively under that tree with the client leaning against it.

In all of the head-and-shoulders poses that appear in this book, the lighting correction was dealt with in a variety of ways, and each solution was determined by evaluating the easiest means to achieve our desired end. The choices may not have been the same as you would make, but they worked out well based on the conditions I was given and the clients' expectations.

Sunlight isn't the first choice for a main-light source. Here, however, we used a small beam of sunlight, which came through trees and a window, to produce a spotlight effect. This focuses the viewer's attention on the young lady's face.

Indoors, shadows typically need to be filled. Also, high ISO settings are required—along with shooting from a tripod.

■ INDOOR SETTING

AS YOU ENTER AN INTERIOR

LOCATION, YOU HAVE SEVERAL

LIGHTING CHOICES.

As you enter an interior location, you have several lighting choices. Unlike outdoor portraits, interior portraits rely on lighting from flash or the light from the windows and doors (or the light reflected from or through these openings). Flash will provide the least natural-looking lighting; it gives interiors an almost cold look. The light from windows and doors will provide the most natural-looking effect, although the light tends to be warmer than daylight, so you'll need to address the issue of color balance (a topic covered later in this chapter).

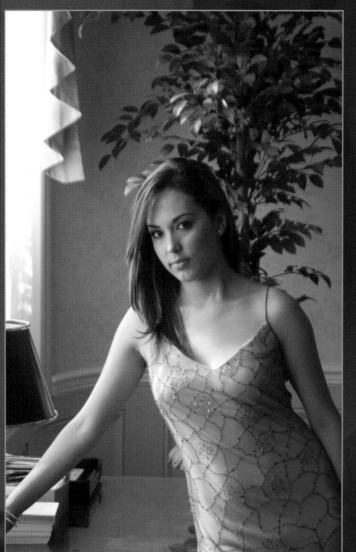

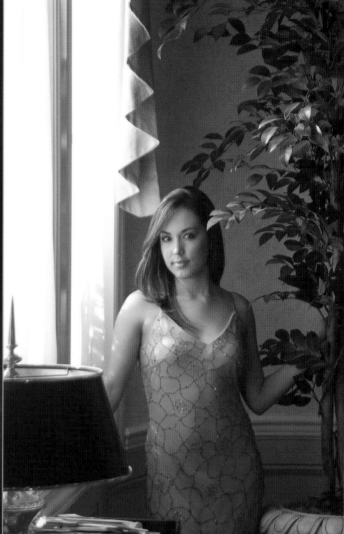

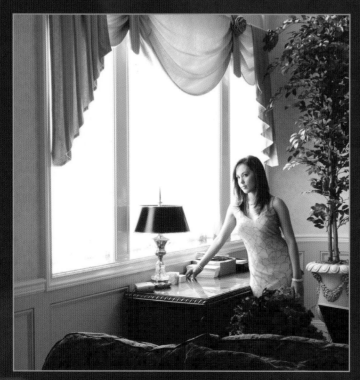

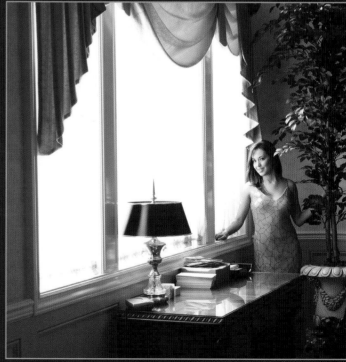

Notice the difference you can make just by positioning your subject in the middle of the window (left top and bottom) versus placing her at the far end of the window (right top and bottom).

This series of images was created in the studio, but it demonstrates the importance of the angle between the subject's nose axis and the main light. In the first photo (left), the light is positioned at a 45-degree angle to the subject's nose and used without any fill. This lights a broad area of the mask of the face, producing only a small shadow area and a reduced transition zone. In the second photo (center), the light is placed at a 90-degree angle to the subject's nose and, again, used with no fill. The shadow area and transition zoned are enlarged. Without diffusion, this doesn't produce a salable portrait. In the third photo (right), the main light remains in the 90-degree position, but fill has been added and the subject's face has been turned toward the main light. This produces a high-quality lighting effect on the face, providing a larger shadow area and transition zone.

Indoors, I mostly use mirrors, reflectors, and the interior lights that the location provides to give my indoor portraits a natural look. Keep in mind that, while you can increase the amount of light coming through any window or doorway (by sending more light through these openings with reflectors or mirrors), the size of the light source and its proximity to the area you will be working in will determine the overall look of the lighting. You should also note that, when working outdoors, we saw that shadows often need to be *created*. Indoors, on the other hand, shadows typically need to be *filled*—just like in the studio. Also, since the quantity of natural light in a interior location is limited, high ISO settings and a heavy-duty tripod are a must.

Two Simple Guidelines. While there are no rules written in stone, you will have an easier time with the lighting if you follow two simple guidelines.

The first guideline deals with everyone's favorite spot in an interior scene: near a window. The light from a large window provides a beautiful lighting source for portraiture, however many photographers don't use it correctly. Most photographers place the subject in the middle of the window, which produces a scenario with too much light coming from behind the subject. For portraits where the subject is looking at the camera, the most control over natural light occurs when you position the subject at the end of the window. This puts the main-light source entirely in front of the subject.

For profiles or poses with the subject looking away from the camera, the subject will need to be positioned with the main light behind them. This same idea should be used in the studio, yet I see many photographers turn the subject to a profile and never adjust the lighting from the setup they used when photographing the subject looking at the camera. This provides

a very flat lighting effect. It's like placing the main light right over the camera with the subject looking squarely into the lens. However you pose your subject, you should maintain a consistent angle between your main light axis and axis of the subject's nose. That way, whether she is looking at the camera or posed in a profile, you will be assured of creating an adequate shadow area and transition zone.

The second guideline is that, when you work inside of a room using light from a window or doorway, you should position your camera *next to* the light source. The closer you can position yourself to the main-light source, the easier the light will be to work with; the further you get from the main-light source, the more you must modify the light to make it suitable for a quality portrait. Light falloff occurs very quickly in the interior of a build-

Light falls off rapidly in interior spaces, so position yourself and your subject close to the light source for best results.

When lighting a profile or three-quarter view like this, your main-light source must come from behind the subject—whether you are working indoors or out.

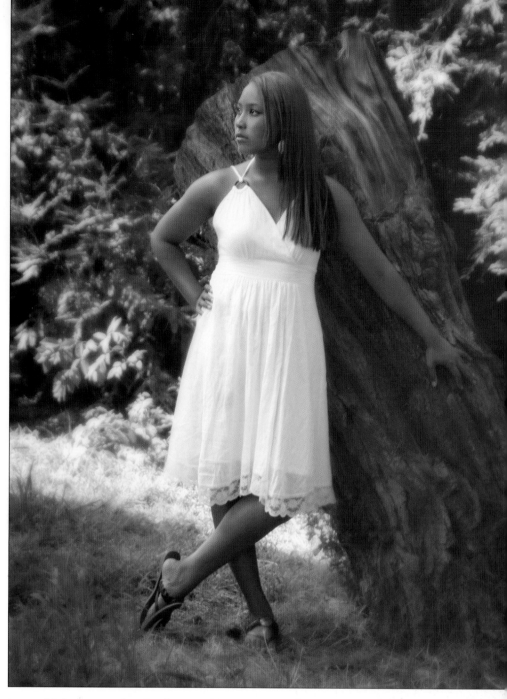

ing, which means that background areas must often be brightened to see detail. Additionally, the subject—especially if he or she has dark hair and/or clothing—will need to be separated to keep them from blending into a darkly rendered background.

Color Balance. Color balancing in an interior can be a little tricky. Light coming from the outside will vary in color, depending on whether the light is sunlight (which will, itself, vary throughout the day) or light from a shaded area. This will also vary depending whether the light is from the open sky (which will be bluer), coming in through a grove of trees (which will have a green cast), or bounced off a building across from the door/window (which will have a color cast that matches the source it is reflected by).

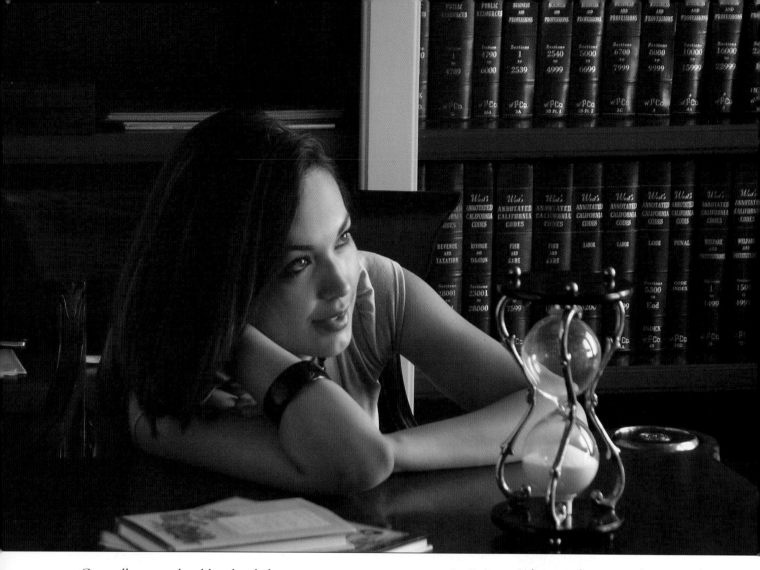

Generally, you should color balance your camera to your main light, then make sure your fill light source has the same color temperature. If it doesn't, your shadow will have a color cast. Luckily, most interior lighting is warmer than the light you'll typically use for a main-light source. So, if this warmer light provides a portion of the fill light, at least you won't see unnatural colors in the shadow. (*Note:* When working with interiors, turn off all fluorescent lighting or you'll get greenish casts in the shadows and on the walls.)

Artistic Choices. When you create portraits at an outdoor location, clients typically don't question the type of foliage you select for their background—I have never had a mom tell me that tree behind her son was a Douglas fir and she was hoping for a Japanese maple!

When working with interiors, you have many more artistic choices. Interiors are much more complex than outdoor scenes. It is not just about figuring out what the predominant lines and textures translate into visually, it is about understanding architecture and interior design well enough to coordinate the interior you select with the overall look the client expects. Then, you must coordinate the clothing of the subject(s) with the colors and

When you shoot at a subject's own home, you can be sure that the portraits will match their decor.

overall feeling that the location provides. An additional concern is creating a portrait that will coordinate with the client's decor when hung in their home. (*Note:* This is one benefit of using the client's home as a the setting for the portrait; the chance of it *not* coordinating is slim to none!) If you don't understand design, buy some books or start watching HGTV. The designers on each show will explain the look of their designs, why they selected the colors they did, and what other colors would coordinate with the color palette of the room.

Background Selection. The complexity of many interiors makes some photographers resort to boring backgrounds, especially in head-and-shoulders poses. These photographers place their subjects so close to the background that they end up with just a wash of green (or whatever the predominant color is) behind their subject. When selecting a background, the idea should be to separate the subject from the background to create more interest. Then, use depth of field to soften any background elements that compete with the subject.

If you don't mind relighting the entire interior, the background choices at your disposal will be numerous; if you want to shoot with just available light, you will find the background options more limited. For a simple lighting enhancement when working in a client's home, I use a few mirrors to redirect sunlight through windows around the room in which I am working. I position the mirrors at a lower angle so the beam of light hits the ceiling. Because ceiling are typically lighter in tone, this fills the room with soft background light, expanding the number of backgrounds at my disposal.

When shooting on location, I like to move fluidly from one setting to the next without having to backtrack to areas where I have already photo-

If you plan your shoot carefully, you can shoot efficiently and capture a variety of images in each area before moving onto the next location in the home,

graphed the subject. This takes much less time than bouncing all over a location. It also requires studying your location for a few minutes, selecting the spots you will be using, and determining the order in which you will be using them. Once I have determined this, I explain the plan to my assistants. Then, while one is working with me, the other is setting up the next area.

Start in the Doorway. Whether I am photographing full-length or head-and-shoulders portraits, I start off in the doorway of the location. The door provides the largest source of natural light in most homes and is, in most cases, the easiest to work with.

The closer you work to the doorway opening, the softer your light will appear. The more you move away from the doorway and increase the angle between the doorway and the subject's nose axis, the more contrast you will achieve on their face. This will give a more sculpted look to your lighting. The choice is yours and will be determined by your client's expectations and the number of usable backgrounds you have to choose from. I feel comfortable finding two angles for using each light source. Again the angle will be determined by the background elements and the light on those elements.

Practical Example. Let's look at these concepts in practice. In the first few images, we are going to use the doorway. Since there is a porch in front of the doorway (see below), the light is less intense than it would be if the area were wide open to the sky. Knowing this, you have two choices: you can change the ISO of your camera to a faster speed (or, use a faster film), or you can bring in more light through the doorway. I chose to increase the ISO setting, because this makes it easier to work with the natural light in the area of the doorway. If we bring in more light on the subject we will have to increase the light in the surrounding areas, as well as in the area that will be our background.

THE DOOR PROVIDES THE LARGEST SOURCE OF NATURAL LIGHT IN MOST HOMES.

Because this home has a porch, the light levels at the front door area are quite low.

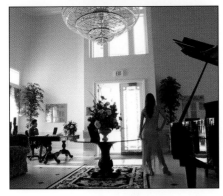

To create the final image (right), we shot from just outside the door (top). The subject was posed with her body turned into the room and her face turned back toward the open door (above).

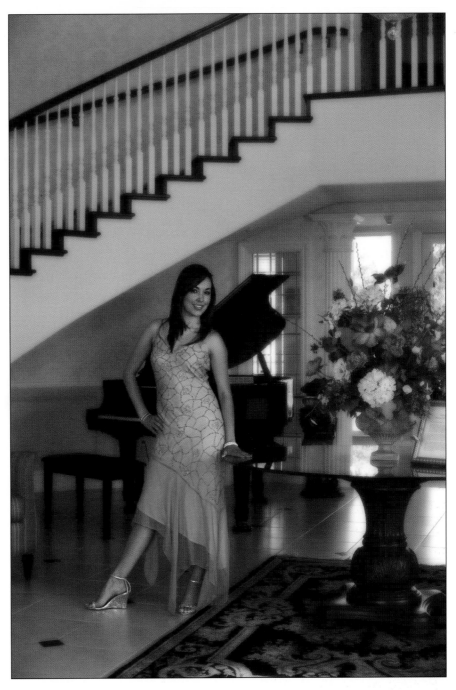

Using the light from a doorway, the background area is usually limited to the depth of the entry area or foyer. In some homes, this can be large, but in most houses this area is only a few feet deep.

In the image above, we posed the young lady with her body facing into the room and turned her face back into the light of the doorway. To fill the shadow and avoid any color imbalance we placed a white reflector on the shadow side of the subject. (*Note:* A white reflector will always give you the same color temperature of light as the main light. If we had used a flash or allowed the ambient light to produce the fill, it would have had a different color temperature than the main light.) We then metered the background

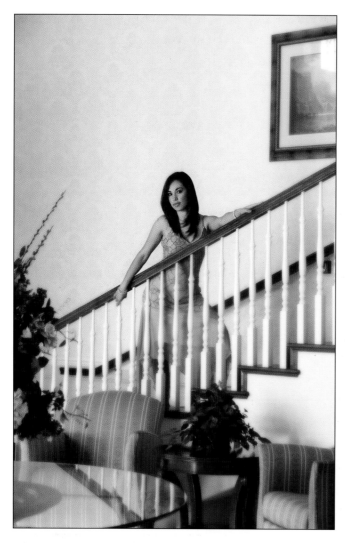
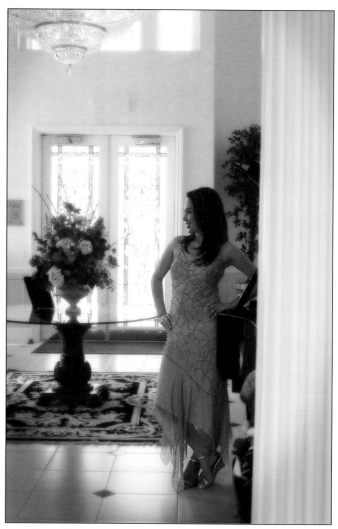

area to make sure there would be enough light to make it usable. The area was a little dark, so we placed a mirror to reflect back the light coming from the doorway. Again, the color of the background did not change because the color temperature stayed the same.

Moving further into the house, there was a window that I knew would provide a nice lighting effect for the type of image this client wanted. To create the shot (above, left), I positioned myself against the same wall as the window. Most photographers in this position would take a profile, but clients don't usually buy profiles, so we had the subject turn her face toward the window light but looking back at the camera. The light was so soft that a fill source wasn't needed. As we metered the background, we found the light on the background wasn't sufficient to bring out detail in the room's interior, so we placed a few mirrors around the home's windows to brighten the background areas.

For the last portrait (above, right) we moved further into the room. For this shot, I needed to add to the light coming from the doorway. Using a silver reflector to bounce the sunlight through the doorway gave us enough

In the first image (left), the light was so soft that a fill source wasn't needed. In the second image (right), using a silver reflector to bounce the sunlight through the doorway gave us enough illumination to use the interior of the room.

illumination to use the interior of the room. When using this technique, it's best to select windows that are behind the subject—that way, the very worst thing that can happen is that you'll produce separation lighting. You must also avoid creating hot spots on the ceiling. This is done by changing the elevation and angle of the camera's position.

Keep in mind that the farther you have the subject from the window or doorway, the softer the light appears. This is the opposite of working with a flash source, like a softbox. With the flash, the intensity of the light can be adjusted to compensate for the increase in distance. When you move your subject further from a door or window in an interior image, you will find that the intensity of the light decreases to a point that the ambient light in the room is almost the same as the light from the doorway or window. This means that the level of the fill light is almost the same as the level of the main light, which gives you extremely soft, almost flat lighting.

In this case, the ambient light alone could have acted as the fill source. However, it was a funky mixture of room lights, light reflected off colored walls, and light from outdoors. To keep the color of the shadows neutral, I added a white reflector to bounce the main light and fill the shadows.

I use the same theory of lighting in almost any head-and-shoulders pose. Available light provides the most natural-looking images, because you can immediately see the lighting effect on the face. Whether the main light is provided by the scene, modified with a reflector, or mirrored through a scrim, the lighting effect will be completely natural in the final portrait—something that isn't always possible when using flash.

THE LEVEL OF THE FILL LIGHT IS ALMOST THE SAME AS THE LEVEL OF THE MAIN LIGHT.

Available light provides the most natural-looking images, because you can immediately see the lighting effect on the face.

8. FULL-LENGTH POSES ON LOCATION

As we begin looking at full-length images, it's important to note that, as professional photographers, we must become skilled in matters of fashion and design, as well as in the abililty to cater to human nature.

A full-length pose requires the correct clothing selections and some careful coordination between the background and pose to ensure that the focus of the portrait remains on the person and not what the person is wearing or what is in the background. Compared to a head-and-shoulders pose, in a full-length image, the client's face is smaller but the clothing and scene take up more of the frame. Backgrounds that would be completely out of focus with the average close-up will be much sharper, showing all the lines, textures, and patterns—so you had better evaluate and place them carefully!

Also, if you pose a young woman for a full-length portrait, you better know exactly how to make her look as thin as possible. The photographer is responsible for everything that appears in the frame. If your client brings in the wrong clothing, it's your fault. If she doesn't look trim and attractive, it's your fault. Problems like this stem from a lack of communication; they didn't know what to do, and you didn't tell them.

While your planning skills must be in top form for full-length portraits, the lighting involved is actually simpler. In a head-and-shoulders portrait, the lighting is *critical*, because the eyes and face are so visible in the final print. This means that even slight imperfections in the lighting will be obvi-

THE CLIENT'S FACE IS SMALLER BUT THE CLOTHING AND SCENE TAKE UP MORE OF THE FRAME.

When creating a full-length portrait, the lighting becomes simpler, but the clothing selection, posing, and choice of background becomes even more critical.

After taking a full-length shot, don't forget to compose a head-and-shoulders view of the same image. Since we started doing this, we've had bigger sales and fewer requests for reshoots.

A sitting or kneeling pose (as seen on the facing page) is often a good choice; it shows the subject's entire body and outfit while keeping the size of the face larger in the frame.

ous. With the smaller facial size of full-length portraits, the lighting still needs to be *good*, but things like slight differences in color temperature, the quality of the shadowing and transition zone, and the look of artificial light sources combined with natural light will all go unnoticed. This doesn't mean you can use an on-camera flash and produce professional results, but you *can* use professional flash more effectively and make it blend with the natural light of a scene.

Keep in mind that, while full-length poses allow you to show some beautiful scenery around the subject, moms always want *the face*. Therefore, with every full-length pose, you should also take an image that is closer. A good idea for posing the client it to use sitting and kneeling poses. This essentially compresses the body, keeping the facial size larger while still showing the entire person. These poses make my seniors happy (because they see their

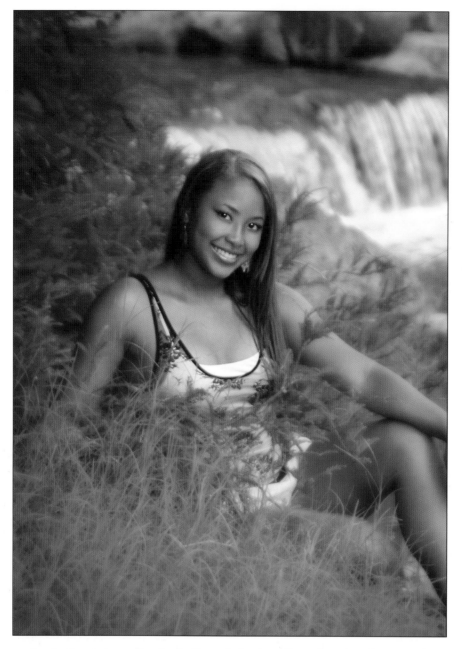

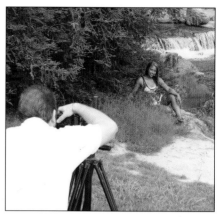

You may not encounter many "perfect scenes," but when you do, working with them can make your job very easy. For a simple variation on this pose, see the image on page 32.

entire body and outfit—including their shoes!) and make their mothers happy because the face is so much larger than the typical standing full-length pose. These poses also give you the great ability to hide the problem areas that virtually all paying clients have (for more on this, see my book *Corrective Lighting, Posing & Retouching for Digital Portrait Photographers, 2nd. Ed.* [Amherst Media, 2005]).

■ **OUTDOOR SETTING**

When I go to an outdoor location, I set up my lighting for all of the different areas that I will be using for that time of day. Normally, I set up: a natural light area; the outdoor photo booth (described in the previous chapter) for backlit, waist-up images; and one or two areas for full-length portraits

THESE POSES GIVE YOU THE ABILITY TO HIDE THE PROBLEMS VIRTUALLY ALL CLIENTS HAVE.

created using flash. As the light of the day shifts, I change locations and modify the lighting—but I can often photograph two, three, or even four sessions without changing the basic locations I first selected for the portraits. This lets me go from area to area quickly without having to set up my lights and equipment over and over again.

Perfect Scenes. While the vast majority of scenes are lacking in some way and need correction to provide a professional-quality portrait, there are some locations that don't require any additional lighting. These scenes are like professional models—they are so perfect that any photo student could produce a beautiful portrait just by capturing what is there. If you happen onto one of these "perfect scenes," count your lucky stars—and take advantage of the opportunity!

Flash Outdoors. When I use flash outdoors I use the same lighting setup I use in the studio. In the main light position, I use a large softbox, Octobox, Starfish, umbrella, or a reflector to bounce light off. The main light I use most often is an Alien Bees Octobox, equipped with the most powerful Alien Bees head I own, allowing me to balance even the brightest scene.

Then, I place a smaller softbox on the ground to provide a similar lighting effect as described in the previous chapter, where we used the natural light paired with a reflector under the face of the subject. The light on the

Controlling the contrast in your image helps to reduce the shiny patches that can appear on subject's skin when working in hot, humid outdoor conditions.

If I am working with an obstruction near the subject, as seen on the facing page, I take a reading to measure the amount of light on the side of the obstruction; that will be the amount of fill I have to work with. See pages 110–11 for more on this shoot.

See pages 110–11 for more on this shoot.

I START BY TAKING AN AMBIENT READING ON MY LIGHT METER FROM THE SUBJECT POSITION.

ground must be feathered off the ground between the softbox and the subject or it will blow out the foreground area directly in front of it. I often use a Westcott-Apollo softbox and a background stand to get the light off the ground and allow me to angle it toward the subject and away from the ground.

Contrast. Most of the time, the white diffusion panel in the front of the light box is left on; this makes its output a better match for the lighting around the subject, which is typically quite soft. When I pose the subject in a backlit scene with a majority of the scene and subject in direct sunlight, however, I will take the diffusion panel off to balance the more contrasty background with that produced by the flash. With film this used to be a problem, because adding contrast (by taking off the front diffuser) increased the amount of shine on people's faces; with no climate control outdoors (i.e., no air conditioning), this always seems to be a problem. When I used film, I would instruct all clients to put on translucent powder to minimize the shine problem. Yes—even senior guys would have their mothers apply it for them. I instructed them to do so and explained the benefits to them—as well as what would happen in their portraits if they didn't (and how much artwork to correct the problem would cost!).

Metering. When using flash, metering the scene for a full-length portrait can be a little confusing. I start by taking an ambient reading on my light meter from the subject position back toward the camera. I also take two additional readings: an ambient reading of the background, and a reading with the incident dome pointed up to the sky. This allows me to visualize the light intensity and direction from each angle. Based on this, I can decide on the lighting I need to balance the scene.

If I am working with an obstruction near the subject, to one side or the other, I also take a fourth reading to measure the amount of light on the side of the obstruction. That will be the amount of fill I have to work with. Most photographers working in this situation just use the calculated amount of ambient light from the subject to the camera as the amount of fill they have to work with—and this is why so many portraits have dark shadows and no transition between the highlight and the shadow. Unless it is white or silver, an obstruction to the side of the subject acts as a subtractive light source, darkening the shadows. If you don't account for this, you will be very unhappy with the results.

If I have a bright background that needs to be darkened with flash and an obstruction to one side on my subject that provides little light for the fill side of the frame, I simply place a reflector to bring up the shadow side of the subject to the level I need. A related problem can happen when the obstruction is white or silver. In this case, if the extra light from this source is not calculated into your lighting setup, it could eliminate your shadow area. This

In most situations, you'll find that you need to increase the light on the subject to keep them in balance with the background. To see this same location used with a different pose, see page 121.

problem can be fixed simply by putting in a gobo between the reflective surface and the subject.

Balancing the Scene. Once I have metered, I know what I need to do to balance the scene. The first area to look at is the background. If the background light and the main light have the same meter reading, it's your lucky day! Don't expect this to happen too often; when you are shooting full-length poses and working at less-then-ideal times of day (remember, you'll be shooting all day long with this system) this situation rarely—if *ever*—hap-

pens. What usually happens is that you have a background that is almost completely blown out by the midday sun.

If the light from overhead meters at least one stop less than the main light, I can probably use the natural main-light source without flash, provided the background isn't overlit by the sun. If the background meters no more than one stop brighter than the main light, the natural light will usually be acceptable. I say "usually," because a one-stop difference above the main light will be fine if your background is a typical greenery scene; it will definitely *not* be workable if your background is a white building!

With some scenes, the light from overhead will need to be overpowered to keep the forehead from being too bright and to eliminate the shadows

If you have a bright, sunlit background, you will need to add flash to overpower any light from overhead and bring the light on the subject to the same intensity as the light on the background.

under the eyes. If the background *doesn't* need correction, you can compensate for the light from overhead by simply adjusting your exposure; the amount of compensation is usually small enough that it will have little effect on the background.

If you have a bright, sunlit background to contend with, which is typical of a midday outdoor scene, you will need to add flash with an output setting high enough to overpower any light from overhead (except if the sun is directly overhead). This will bring the light on the subject to the same intensity as the light on the background. You can also accomplish this using a reflector, but flash is preferred for full-length portraits—after all, you don't want to blind your clients!

Some photographers get confused about balancing ambient light with flash. While the amount of ambient light that will be recorded is controlled by both the shutter speed and aperture, the flash is mostly controlled by the aperture alone. This makes it possible to overpower the sunlit background without having to use an enormous flash unit. The only limit to this control is the fastest shutter speed at which your camera syncs with the flash.

The Alien Bees Octobox provided an appropriate main light. The fill was provided by the sunlight hitting the grass surrounding the subject.

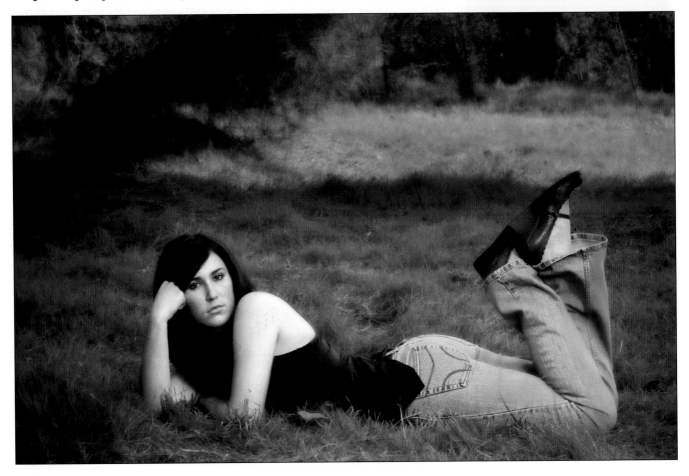

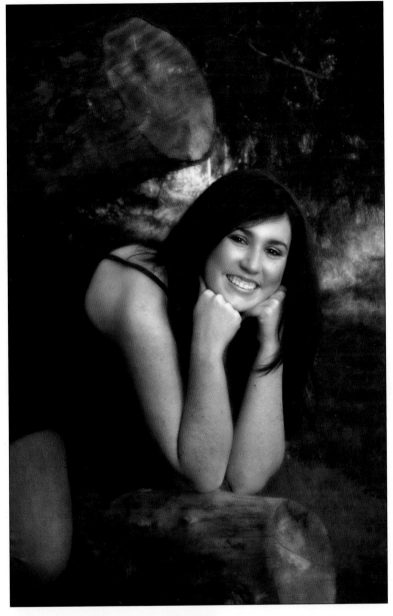

Practical Example. As you deal with lighting outdoor portraits, you will have to modify your approach to fit the scene and the subject's pose. In the outdoor pose on the facing page, the natural light for the subject lacked direction; there was a grove of trees, and most of the lighting came from overhead. With the subject laying on the ground, the lower light that I typically use outdoors was turned off to avoid the grass in front of it becoming overexposed. That would have given the scene a very unnatural look.

When I metered this scene, I wanted to keep the sky and background from washing out. Using an exposure of $\frac{1}{125}$ second at f/11 produced attractive lighting on the face while maintaining beautiful lighting on the background and the rest of the subject. The single flash with a Alien Bees Octobox provided an appropriate main light, and the front diffuser was removed to increase the contrast and make the light on the subject match the look of the sunlit background. The fill was provided by the sunlight hitting the grass around the subject.

In this same area, I created a second image of the senior up off the ground on a tree limb (left). For this image, I used the same main light, but added a smaller Westcott Apollo for the lower light. I metered each of these lights separately. The main is always 1.5 to 2 stops greater than the lower light. Once we establish the ratio of lighting between these two lights, we then meter both lights together and use that combined reading as the amount of light to balance the background. For example, if the main light reads f/11, then we would start out with the lower light metering f/5.6. Then, once we get both lights adjusted, we meter both units when fired at the same time. In this case, it was almost f/16. After metering the background, I can then set the aperture at f/16 and adjust the camera's shutter speed to lighten or darken the background as desired.

Checking the Exposure. Back in the days of film, you had to be very efficient with meter readings to make this type of lighting look natural outdoors. With digital we have instant previews, which makes life much easier. I get everything metered the way I want, then use the preview to fine-tune

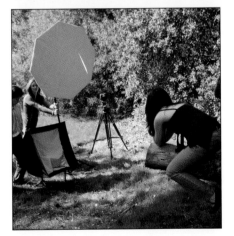

Here, I used the same main light, but added a smaller Westcott Apollo for the lower light.

the lighting to get the exact look I want. To make this process as accurate as possible, an LCD shade is an excellent investment. It is a bellows-type shade that completely covers the LCD screen. It also features a magnifier for easy viewing. This really helps, because trying to see your preview in glaring sunlight is almost impossible.

You must also watch your histogram. A preview is nice, but often an image looks fine on the LCD and it isn't until you bring it up in Photoshop that you realize how dark it is. Checking your histogram will help ensure that you are using as much of the complete tonal range as possible.

Keep It Simple. Although photographers love fancy equipment and the idea of pulling out "the big guns," don't forget the old words of wisdom: "Keep it simple, stupid!" (also called the KISS principle). When one reflector will give you a salable portrait, don't use anything more. In the photos on the facing page, the side of the hill was backlit with direct sunlight on all the grass and the subject. (*Note:* Foliage always looks best when backlit; it brings out the most vivid colors.) I didn't want to completely overpower all

ENSURE THAT YOU ARE USING AS MUCH OF THE COMPLETE TONAL RANGE AS POSSIBLE.

With digital, you can use the LCD screen and histogram to ensure that you have a proper exposure.

If a simple reflector is all that is needed to create beautiful lighting on your subject, why would you want to use anything more complicated?

this beautiful light, so a simple white reflector, placed close to the subject and bouncing back the sunlight, was just enough to beautifully light the face without overpowering the backlight.

A Common Problem. At midday, a common problem is backgrounds that are partially lit by the glaring rays of the sun and partially in heavy shade. In this situation, if you try to use flash to balance your subject with the brightly-lit areas in the background, the shaded areas will most often end up black or near black with little or no detail. Therefore, you have two choices. You can either rotate around the subject with the camera and use

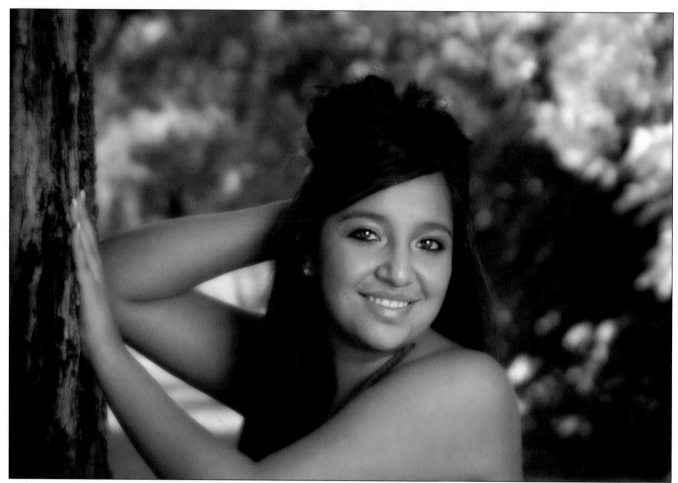

the area that is in heavy shade, or rotate the opposite way and use the area that is in direct sun. Working in the midday hours, you have to constantly use camera angle, camera height, distance from the subject to the background, and the length of your lens to isolate the usable areas of a scene for the background.

An Additional Tip. If you have a background that is perfect but has areas lit by both sun and shade, digital technology offers you a way to make it work.

In the first image (top left) the background has both very light and very dark areas. Moving to the right (top right) did not produce an acceptable background either. In the final image (above) repositioning the camera so that the background was filled with dark foliage produced a much better image.

To use this technique, you must shoot from a tripod. Once you set your camera position, don't adjust it. Take all your shots of the subject in that pose and position, setting your lighting to ensure detail in the shaded areas. Then ask the subject to step out of the frame. Once the subject moves out of the frame, adjust the exposure so the sunlit areas appear properly exposed and create another exposure of the scene without the subject.

After the shoot, open both images in Photoshop. Place the image with the client properly exposed over the image that has the sunlit areas of the background properly exposed. Then, select the Eraser tool and erase the blown-out areas of the top (subject) image to reveal the properly exposed sunlit

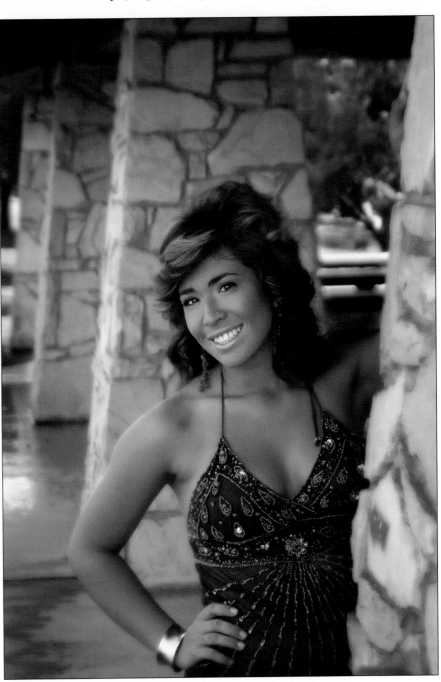

In the original image (top) the background was too light. A second exposure was made (without the subject; above) to render the background properly. Then, the two images were combined in Photoshop to produce the final image (right).

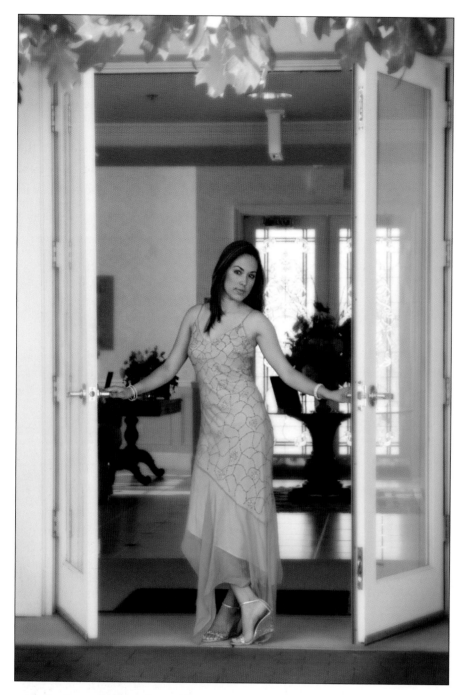

Under the porch and just outside the doorway, the unmodified light in this area worked well for a full-length portrait.

areas in the underlying layer. This works well—provided you don't move the camera during any of the exposures.

Full-length outdoor portraits test your skills as a professional photographer; you must control the light over a larger area, make the client look beautiful with more of the client showing in the portraits, and make sure that the clothing, background, and pose don't visually compete with the subject's face. This requires planning and attention to all the details. As we move on to discuss full-length images created indoors on location, the number of variables changes. This is because interior spaces have many more designer pieces put into a much smaller space.

FULL-LENGTH OUTDOOR
PORTRAITS TEST YOUR SKILLS
AS A PHOTOGRAPHER.

Creating full-length portraits indoors usually means that you will have to light not just the subject, but also the interior itself. You may get lucky and find yourself in an interior space that has massive windows all facing toward the north and flooding the interior space with light . . . but, as with the perfect outdoor location, that doesn't happen very often.

Emulate Natural Patterns. Here's the golden rule when it comes the bringing light into an interior space: look to the windows and doorways. This will show you where to bring in your light—whether it's bouncing it in

Here, the large French doors provide good lighting for a full-length portrait. Indoor locations like this—places that can be used without modification to the lighting—are relatively rare.

from the outdoors or placing flash units indoors. The people who live in the home where you are working are used to seeing the light patterns that are naturally created by the doorways and the windows. If they've chosen a special location for their portraits, it makes sense that the area should look like they are accustomed to seeing it.

As briefly discussed in the section on head-and-shoulders portraits created indoors, when I am going to add light from outdoors, I often aim mirrors through the windows or doorways to bounce light into the interior scene. However, mirrored light needs to be softened to be usable, which means it has to be reflected off of a wall or ceiling. While this works well for a head-and-shoulders portrait that shows only isolated parts of the interior scene, full lengths show much more of the room and the mirrors often make visible hot spots on the ceiling or walls. Therefore, although I do at times bring in light through the windows to light up a portion of the scene, I most often use flash for at least the main light when shooting full-length poses.

An effective way to light an interior is to go to each window in the area where you will need additional lighting and put a strobe directly over the window. Then, use either a white umbrella, or, if the walls are lighter, just bounce the light off the wall. This will give you additional light that matches the softness of the window light that the occupants will be used to seeing in the area.

Placing your flash over a window ensures that your lighting will match the direction of the natural lighting in the room.

As with outdoor portraits, indoor portraits have a better sense of depth when foreground elements are included.

Look for Additional Sources. The natural patterns of light are important, but you must also look at the unnatural sources of lighting. Many buildings are designed to showcase the natural lighting; others are designed to have more subdued natural light and make extensive use of interior lighting systems to direct your eyes where the designer wants them to go. These lighting systems provide a pattern that clients see as the correct lighting for the room. If you go through and add flash to each window or doorway, you will change the pattern of the lighting.

Working in this type of space—an area with its own lighting system—is more difficult than creating a portrait in a building that features more natural light. You can use the existing system to light the interior of the room, however this typically induces a yellowish-orange or green color cast (with incandescent lights and fluorescents, respectively).

THESE LIGHTING SYSTEMS PROVIDE A PATTERN THAT CLIENTS SEE AS THE CORRECT LIGHTING FOR THE ROOM.

There are two ways to deal with the problem. First you can replace the light fixtures with small strobe units that have a household-bulb base. These are very inexpensive. Once they are installed, you can simply white balance your camera to the color of the artificial light. You can then add the proper color filter to your main-light source to balance the artificial light sources.

You can also fix the imbalance in Photoshop after the shoot, using the same technique we employed on pages 93–94 to deal with an unevenly lit outdoor background. First, white balance the camera for the light on the subject and take the needed shots of them in the scene. Then, ask the sub-

Unique backgrounds abound in interior settings. Here, the leaded-glass doors provide both the background and the main-light source for the portrait.

Darker interiors like this one call for darker clothing; brighter ones (as seen in the image on the facing page) work best with lighter colors.

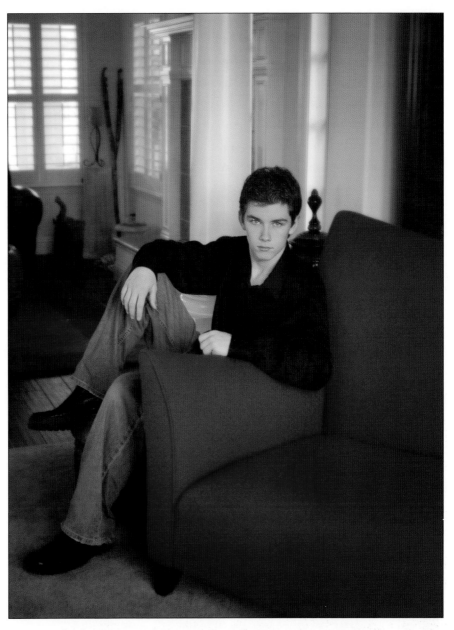

ject to exit the space and change the color temperature setting to give the room its best look. This usually entails neutralizing some of the color in the room lights. In Photoshop, place the image with the subject over the image of just the background, then use the Eraser tool to remove the overlaying background areas that have color casts, revealing the more neutral color underneath.

Evaluate the Light Intensity. In addition to the natural light patterns and color temperature of the light, you also have to look at the intensity of the room light, both natural and artificial. Should the room have a darker appearance, then that is the way it should appear in your portraits. Problems start to occur when the photographer tries to lighten or darken an interior space to create a particular feeling and change the way the room naturally appears.

Coordinate with the Setting. The overall feeling that an interior space or scene reflects directs how you will have your client dress and pose. If the room is bright and airy, then it should appear brighter in your portraits and your clients should select clothing in a lighter tone to coordinate with the room. If the room is darker, you should have your client select darker clothing to coordinate with that look.

Some interior spaces appear very formal. These should be paired with more traditional posing and clothing. Other interiors are very casual and should be paired with comfortable clothing and seated, laying, or generally more comfortable posing.

If the client hires me to come to their home, then I work with the setting I am given and coordinate everything I do to that. If I select the indoor loca-

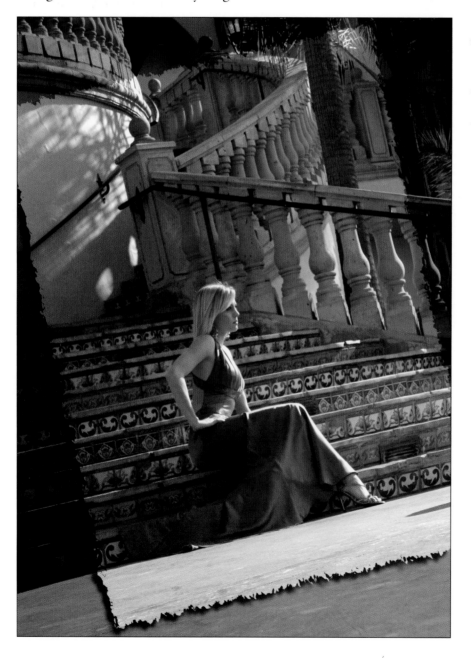

The pairing of a stunning dress and an elegant scene (not to mention a strikingly beautiful girl) make this image work. In this pose, I used direct sunlight to create a unique profile lighting effect. The fill was provided by the direct sunlight bouncing off the ground and the building to the left.

While the bright pink color looked great on the young lady, it didn't coordinate with the late fall look of the outdoor location. We found a background that was still green and used the sun as a backlight to give the portrait a spring look that fits the color of her top. We finished with a glamour glow effect in Photoshop to complete the image.

tion myself, then I look for a spot that offers a variety of scenes in different styles. This allows me to increase the variety in my client's session. As you'll recall, we do the same thing in our outdoor locations.

■ IN CLOSING

As we finish our discussion of lighting a portrait on location, I have two important suggestions.

First, if you want to improve your location photographs, practice on your own time. No one can improve their technique while photographing a paying client—nor should you. When a client pays for your service, you should not use them as guinea pigs in your learning process.

Second, while you are practicing, I suggest avoiding the use of any scene or area that you have used before. You've already conquered the challenges found in familiar locations, so if you have to re-use one (or do your test shoots in a similar area), at least try to experiment with different camera angles, elevations, and styles of subject posing. That way, you will be forced to grow creatively.

In the next few chapters we won't be discussing how to light portraits on location—but our topic is just as important: surviving and profiting from photographing at outdoor locations.

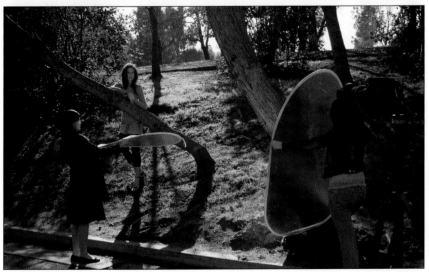

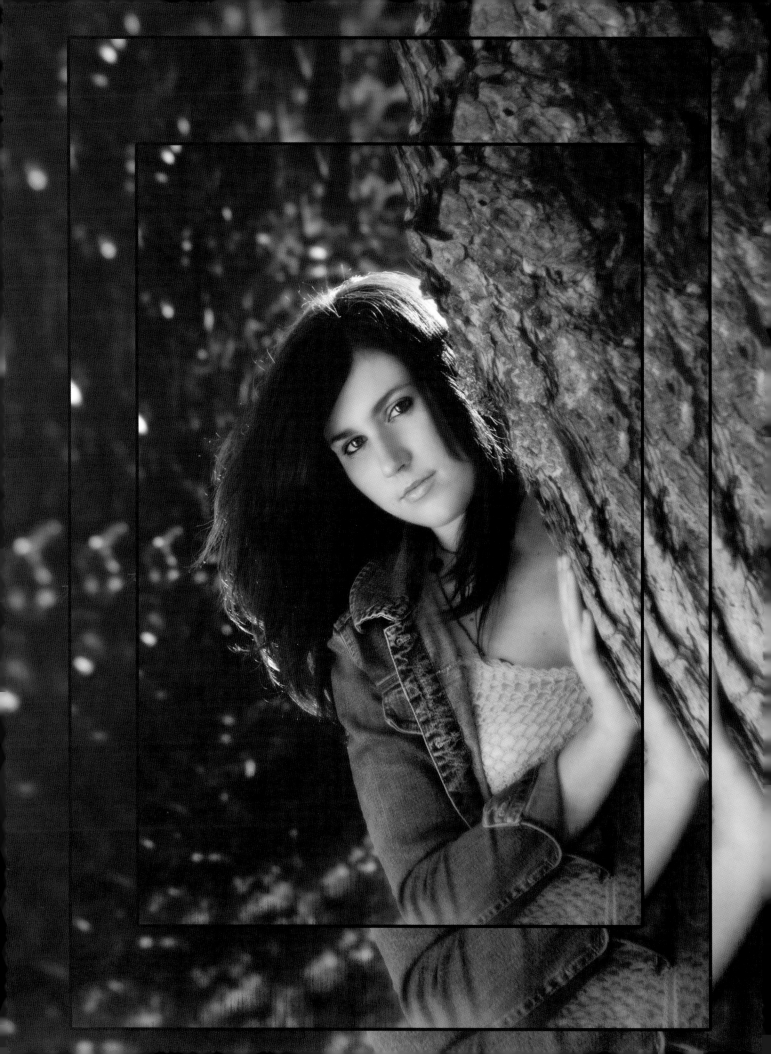

9. ADDITIONAL CONSIDERATIONS

As a businessperson, there are many factors to consider when you start offering location portraits and begin selecting the locations you will use. In this chapter, we'll look at some common concerns and problems.

This is the classic peek-a-boo pose with a strong backlight to highlight the hair, a slight breeze to give the hair additional body, casual clothing, and a mainlight provided by a reflector. While this is a very salable image, I prefer the multiple-image look.

■ DON'T NEGLECT SAFETY

Safety is the first concern. While urban scenes and downtown locations make for some interesting location photography, in some cities these locations can put you (with all your expensive equipment) and—more importantly—your *clients* at risk. Even public parks in questionable neighborhoods can pose undue risk. Male photographers especially are often prone to a false sense of bravado, feeling that they could fend off any would-be evildoers. You have to ask yourself: Is it is worth losing your equipment, your business (if your client should get hurt), or even your life to create a portrait?

Instead, look for parks, outdoor locations, and interior settings that are in the finest part of your town. This is where your clients are safe. In addition, this will create a better impression of your business. You'll probably find that these are the areas that most of your clients come from anyway, so they are usually very convenient for your subjects.

■ WORK WITH AN ASSISTANT

I mentioned this earlier in the book, but it bears repeating: don't work on location without an assistant. I know of a very good photographer who, like

When selecting portrait locations, keep safety in mind. Working in your area's best neighborhoods creates a good impression of your business and helps to ensure a comfortable work environment.

us, photographs many seniors throughout the year. Unlike us, however, this photographer works with seniors of the opposite sex in remote locations and in home settings without an assistant, and without a parent present. To me, this is asking for trouble. In today's world, even an unsubstantiated, false allegation is enough to ruin a successful business. Why take that chance?

I always work with one if not two assistants, and we insist that a parent accompany the senior throughout the session. I don't care if Mom reads a book under a shady tree, as long as she is nearby—insisting that a parent comes with the senior shows our professionalism. Additionally, Mom is there to help her daughter with her clothing. If she needs help with a zipper, I want Mom there, because I don't always have a female assistant.

EVEN AN UNSUBSTANTIATED, FALSE ALLEGATION IS ENOUGH TO RUIN A BUSINESS.

■ PROVIDE A CHANGING AREA

You need to make provisions for your clients to change their clothing. We have a changing tent, which is very convenient for our clients. You should make your changing area as comfortable as possible for your clients. We bring an ice chest with cold water and sodas, as well as wet wipes, hair spray, hair pins, and disposable combs.

Some photographers use public restrooms for this purpose, but public facilities are often dirty and unpleasant. Additionally, they are public places, so anyone could be in them. I never really thought about this until a ring of male prostitutes was arrested working out of one of the public-park restrooms in my area. Does this seem like a place you would what to send a seventeen-year-old high-school senior? I don't think so!

Whether you're shooting indoors our out, it's a sensible precaution to work with an assistant. With minors, a parent should also be present.

■ PREPARE YOUR CLIENTS

We give our clients my cell-phone number so they can reach me in case they are lost or running late. They also receive a map to the location, along with

driving directions from the north, south, east, and west of the location. Additionally, our web site provides complete information about the locations we usually go to, along with directions to each of the locations.

■ GET CLIENT INPUT

Because we don't have a waiting room like at the studio, I encourage seniors to visit our web site and print out some of the outdoor ideas they like the best, then bring them to the session. This gives me some direction and helps to ensure they'll like their images. I also explain that certain areas are not available at certain times of day. I don't want a senior to be upset because we can't do her favorite scene at the time she chose for her session. It is also important that your web site image galleries and studio display prints show only the locations and areas you currently offer. Any outdated images should be removed immediately.

Keep in mind that, for many sessions, you need to please multiple buyers. For example, at a senior session, the teen will want certain images, while the mother and/or grandmother will want completely different ideas. To get

We encourage clients to visit our web site and print out some of the ideas they like best. At the shoot, this helps us decide what poses and scene will best suit their tastes. For a simple variation on this pose, see the image on page 122.

the most from each session, you must satisfy both buyers. Ask your clients who the portraits will be for and where they will be displayed. Try to learn everything you can to help you give your clients the end products they want.

Always begin with the end in mind. While "the end" for the client is getting the images that they want, "the end" for you is getting the money that will pay your bills and put your kids through college. As I said in the beginning of this book, there are way too many photographers that can take pretty pictures and not nearly enough that can make a good living in this profession. This is the topic of our next chapter.

At many sessions, you need to please multiple buyers. Variety is the key to accomplishing this goal.

10. PROFITING FROM LOCATION PORTRAIT PHOTOGRAPHY

The number-one priority of any business is to generate a profit. Without profit, you don't have a business, you have an expensive hobby. That said, learning how to make a profit should be at the forefront of each photographer's thought processes. Unfortunately, that's often not the case. As artists, most photographers are much more excited about the creative aspects of photography than they are about learning the skills they need to build a profitable, sustainable business.

Of all the many books I have written, I think that the most important one for the average photographer is the one called *Success in Portrait Photography* (Amherst Media, 2003). In that book, I discuss every aspect of being a success in this profession and running a profitable company. This is critical information that almost every studio could immediately benefit from—yet each year, the book's total sales are well below those for my other publications that concentrate on posing and lighting. Why? It's because, in our hearts, we believe that if we are just good enough at posing and lighting, the business will come.

This is a dangerous mistake to make if you want to stay in business. Without a solid plan for creating profit, you can produce the most amazing pictures in the world and it won't pay your mortgage, feed your kids, or put clothes on your back.

■ BUSINESS FIRST, CREATIVITY SECOND

I have always loved working on location. In the early days of my career, however, I found that the way I was offering location photography to my clients wasn't actually profitable. This was because I had learned how to photograph outdoors from photographers who erroneously put the *creative* process ahead of the *business* process. While these photographers taught me a great deal, much of *their* income actually came from speaking and endorsements, not from running a successful photography studio. I didn't have that benefit; I needed to make my living from the pictures I was creating. (*Note:* Today, other photographers always ask me why I don't speak more or offer seminars. The truth is, I have found I can make a lot more money working in my studio than I can speaking—even with the sale of books and tapes after the class. I am booked with sessions and events throughout the year, so for me to speak, I would have to turn away more profitable work.)

Without a solid plan for creating profit, all the pretty pictures in the world won't help you create a successful business.

Learning to work with available light throughout the day is a key element of profiting from location portraiture. See page 85 for a head-and-shoulders image from this shoot.

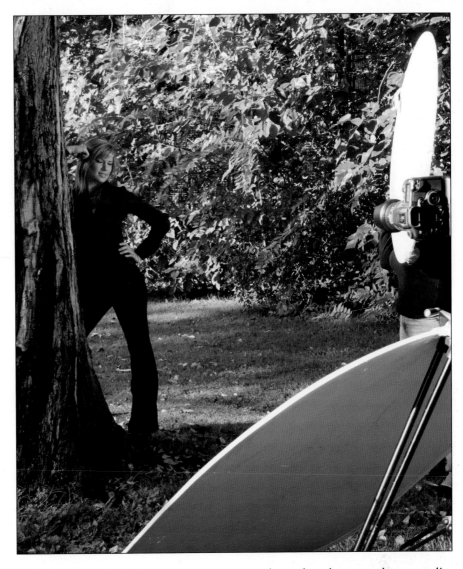

YOUR AVERAGE ORDER MEANS

NOTHING UNTIL YOU PUT IT

INTO THE CONTEXT OF TIME.

A few years back, I was at a program where the photographer was discussing his sales averages—and I had an important realization. The photographer said that his average senior order was around $1000. This immediately got my attention; with the number of seniors we photograph, that would be some serious money. However, as I listened to him explain the process he went through with his seniors, I suddenly realized the problem: he was spending hours and hours with each client—he met with each senior personally, planning the session and giving a studio tour, then he spent about three hours photographing each one. Considering all the overhead in photography, if you're spending five hours to generate a $1000 sale, you're in trouble. I quickly realized that I was listening to someone who put the creative process ahead of the business process.

■ WHAT'S YOUR ACTUAL PROFIT?

In a photography business your average order means nothing until you put it into the context of time. If you want a meaningful number, you need to

While the creative process is important in creating images like the one on the facing page, if you don't prioritize the business aspect of your studio, your business won't live up to its potential.

add up every session you book for a client type—say, senior portraits or weddings. You must include in this number no-shows and people who don't order. Then, divide that number by the total sales from that client type. Most photo-educators only talk about the clients who order, which is why their averages sound so much higher than those in most studios. However, your time is involved in every session booked—even no-shows. Every client takes time and, as you will see, time is your most precious resource.

Billable Hours. Most people think of an average work week as forty hours, five days a week, eight hours a day. However, no one actually works this many hours. There are days off for vacation, sick days, and holidays, and there hours each day that need to be spent doing things that don't directly generate profit—answering e-mail, managing employees, etc. These activities all cut into your billable hours. So, let's say that you will photograph

You have a limited number of billable hours, so you need to maximize every moment.

Outdoor portrait photography can be extremely profitable—but only if you have efficient shooting practices and a solid business plan.

twenty-five hours a week—roughly five hours a day, five days a week. Over the course of a year, that means you will have about 1300 billable hours (and that's if you work all fifty-two weeks of the year).

Real Profit. Now that you know the total number of billable hours you have per year, the next step is to pull out last year's books or even your tax return. From these numbers, you can figure out what percent of each dollar that comes into your business is yours to keep. It's not that difficult. For example, let's imagine a studio that took in a total of $200,000 last year. For the same year, the studio's total expenses (money paid out for rent, salaries, supplies, insurance, and every other expense) were $170,000. This means the studio's profit after expenses was $30,000.

Hourly Sales Averages. Knowing this, we can see that this studio would need have to have $400,000 in sales to generate $60,000 in profit. Let's say

that this was the goal. What would have to happen for it to be achieved? Well, if you simply divide $400,000 by the total billable hours (1300), you'll see that to reach this profit level, the studio will need a sales average of just over $300 per hour. (*Note:* Your actual numbers might be higher or lower depending on your business expenses. On average, though, you can figure that 15 percent of every dollar is profit; that was the standard used when creating this example.)

So, let's return to the example given above. If the speaker who bragged about his $1000-per-session sales average was spending five hours with each client to get it . . . well, there doesn't really seem to be much to crow about, does there? Assuming an average rate of, again, about 15 percent, we can figure that his annual profit is only about $39,000. If you want to own a nice home and send your kids to good colleges, you're probably going to want to set your sights considerably higher.

Although this is a simplified process, it quickly illustrates an approximate amount you must bring in for each of your twenty-five billable hours per week. Thinking about your prices in terms of sales per hour provides you with a clearer understanding of what it takes to generate an adequate prof-

Simple posing variations can totally change an image—helping you ensure you have the variety you need to please your client and ensure a big sale.

ON AVERAGE, YOU CAN FIGURE THAT 15 PERCENT OF EVERY DOLLAR IS PROFIT.

PHOTOGRAPHERS SEEM TO

WORRY MORE ABOUT PRICES

THAN BILLABLE HOURS.

it. This is the very reason most attorneys are such sticklers about their time. Whether you talk with them on the phone or meet with them in their office, you are taking up their billable hours and you will be charged for that time. Photographers, on the other hand, seem to worry much more about their prices than their billable hours. Remember: Profit is determined by how much you sell your product for *and* the volume of products you sell. You may sell your 8x10s for $100 apiece, but if you don't sell enough of them, or if you take too long to plan, create, and sell them, your business won't prosper.

■ INCREASING YOUR AVERAGES

If you want to increase your true averages (not the made-up ones some speakers use!), you can start today without ever raising your prices. The two killers of profit for any photography business are no-shows (people who

You may sell your 8x10s for $100 apiece, but if you don't sell enough of them, or if you take too long to plan, create, and sell them, your business won't prosper.

Want to eliminate no-shows from your life? Require payment up-front and you can be sure your clients will arrive on time and ready for their session!

make an appointment and, even with confirmation letters and phone calls, do not show up) and those who have a session taken but fail to order.

Eliminate No-Shows. The no-show problem is an easy one to fix: simply ask each client to pay for their session when they book it. Then explain, both on the phone and in writing, that you require seventy-two hours advance notice of any cancellation. If this proper notice is given, the appointment will be rescheduled, but not refunded.

This sounds scary to many photographers, but it completely weeds out the clients who are not serious about being photographed. I remember when we used to schedule an appointment for anyone who called in. Un-

ASK EACH CLIENT

TO PAY FOR THEIR SESSION

WHEN THEY BOOK IT.

fortunately, many of them seemed to think, "Sure, I'll schedule that appointment—if I change my mind, I just won't show up." As a result, we had many clients each week who would call to cancel, using excuses like, "My friends asked me to go shopping, so I won't make it in today," or "I stayed up all last night playing games and I am too tired to come in." On any given day, 20 to 50 percent of our sessions would not show up. At that time, our solution (or at least what we *thought of* as a solution) was to over-book the days, just like doctors do, to ensure my time wasn't wasted. The problem was that, on occasion, *everyone* would show up. Then we would be running way behind at the end of the day—and that was frustrating for both us and the clients.

With prepaid appointments, that doesn't happen. Each client has a scheduled time with me, and they pay for it whether they show up or not. While

Having clients preview and order their images as soon as possible after the session invariably results in bigger sales.

I used to get angry about the time wasted by no-shows, now I just sit back and write or work in Photoshop. I don't have to get angry or be worried, because my time is paid for.

This is especially important when it comes to location photography, because sessions done on location have a higher-than-average amount of no-shows. If you don't currently ask for your sessions to be prepaid, the good news is that most clients will understand the need to prepay an outdoor session even more than a studio one. Should the client be resistant, we just explain that it is the same as booking a hotel room; you must pay up front to have it reserved for you. Likewise, our time is reserved for the client, so they must pay for the session to reserve it.

Try it—it isn't as painful as most photographers envision it to be. There will be a few people who say, "That's ridiculous! The Jones studio doesn't do that." If you hear those words, you'll know that you have just weeded out a client who would not have shown up anyway. During the last year when we scheduled appointments without prepayment, we had one senior who canceled and rescheduled her appointment *eight times* over the course of her senior year! When we finally asked for advance payment on the session, however, she was there thirty minutes early for her appointment.

Ensure Every Client Places an Order. The second issue to address in raising your sales per hour is the way you sell your photography. The "old" way has the client dealing with the purchase of photography as a two-step process. The client comes in to take pictures for a small sitting fee and then takes proofs home to determine if they want to buy them or not.

This is a critical mistake; if you want to make money in this profession, you must *never let any unpaid work leave your studio*—period! When you give client paper proofs to take home, you have communicated to your client that the images have no value. After all, what business would let a valuable product go out the door with charging a fee, or at least requiring a large deposit? Many studios address this issue by having clients leave a $250 to $500 deposit. They figure that, even if the client keeps the proofs and never places an order, the studio has still made its money.

While this is a start, studios that adopt this practice are actually missing out on big sales. This is because the largest orders are possible the first time the client sees their images. When the images are first presented, the client will be excited about the session and emotionally connected to each image—they'll be ready to buy! If the client takes home a proof book, they will spend weeks scrutinizing it and thinking about their finances. As more time passes, their excitement will slowly fade—and so will your sale.

To capitalize on the enthusiasm of the session (and completely avoid having clients fail to order), our clients view and order their portrait packages right after their studio session is over. With location sessions, the client's

When clients view their images in your studio, rather than in a take-home proof book, they have the benefit of working with a trained professional who can help them select the best shots. To see this same location used with a different pose, see page 86.

AS TIME PASSES, THEIR EXCITEMENT WILL SLOWLY FADE—AND SO WILL YOUR SALE.

ordering appointment is scheduled for the next business day.

Viewing the images right after the session is the key to success in this business—but it must be handled correctly. First, clients must be educated about the benefits to them of ordering right after the session. We emphasize that this practice allows us to provide the best possible service, because it allows them to work on their order with a trained professional who can help them through the process. Also, if the client doesn't like a pose from a studio session (which doesn't often happen, because they select the poses they want before the session) we can have them step back into the studio and retake it. While this isn't possible with location photographs, we let clients know that we will take many more ideas than they are "supposed" to have in their session. That way, they don't *have* to like each one—there will be lots to pick from and they can narrow down their selections in the sales room.

This process takes professional photography to another level, because there is no smoke and mirrors—everything in the entire process is out in the open. Accordingly, when your staff members answer questions about your sales methods, they need to know what to say. For example, a classic client comment heard by every studio that does sales right after the session is, "What if I am not ready to order at that time?" In this case, your staff should respond, "Well, then let's make your appointment at a time when you are ready to order." You have to professionally and politely inform clients that this isn't a two-step process; if you like the photographs, you buy the photographs.

If you try these two things, you will see your sales per hour increase and your frustration decrease. If you can combine these two ideas with learning to work with the light at outdoor locations as it changes throughout the day, you will have the potential to not only take beautiful images, but to live an outstanding life.

Both you and your clients benefit from a sales process that is clear and simple. For a quick variation on this pose, see the image on page 106.

THIS PROFESSION HAS ALLOWED ME to live very well for a very long time. I have been able to enjoy my life personally while doing what I love to do professionally. I have seen parts of the world that few photographers will ever see—not because they lack the potential, but because they consider themselves artists first and businesspeople second.

Many photographers will read this book, e-mail me a thank-you note, and use very little of the information; it is human nature to settle—not changing, not growing, and not having to become more than we already are.

Providing clients with high-quality location portraiture, while scheduling it to profit your business, isn't always easy, but it is very satisfying and profitable. I hope you enjoyed reading this book—I hope even more that you use the information to better your business and your photography, which in turn will better your life.

Good luck,
Jeff Smith

INDEX

DIGITAL CAPTURE AND WORKFLOW

FOR PROFESSIONAL PHOTOGRAPHERS

Tom Lee

Cut your image-processing time by fine-tuning your workflow. Includes tips for working with Photoshop and Adobe Bridge, plus framing, matting, and more. $34.95 list, 8½x11, 128p, 150 color images, index, order no. 1835.

MASTER POSING GUIDE

FOR CHILDREN'S PORTRAIT PHOTOGRAPHY

Norman Phillips

Create perfect portraits of infants, tots, kids, and teens. Includes techniques for standing, sitting, and floor poses for boys and girls, individuals, and groups. $34.95 list, 8½x11, 128p, 305 color images, order no. 1826.

WEDDING PHOTOGRAPHER'S HANDBOOK

Bill Hurter

Learn to produce images with unprecedented technical proficiency and superb, unbridled artistry. Includes images and insights from top industry pros. $34.95 list, 8½x11, 128p, 180 color photos, 10 screen shots, index, order no. 1827.

RANGEFINDER'S PROFESSIONAL PHOTOGRAPHY

edited by Bill Hurter

Editor Bill Hurter shares over one hundred "recipes" from *Rangefinder's* popular cookbook series, showing you how to shoot, pose, light, and edit fabulous images. $34.95 list, 8½x11, 128p, 150 color photos, index, order no. 1828.

PROFESSIONAL PORTRAIT LIGHTING

TECHNIQUES AND IMAGES FROM MASTER PHOTOGRAPHERS

Michelle Perkins

Get a behind-the-scenes look at the lighting techniques employed by the world's top portrait photographers. $34.95 list, 8½x11, 128p, 200 color photos, index, order no. 2000.

MASTER LIGHTING TECHNIQUES

FOR OUTDOOR AND LOCATION DIGITAL PORTRAIT PHOTOGRAPHY

Stephen A. Dantzig

Use natural light alone or with flash fill, bare-bulb, and strobes to shoot perfect portraits all day long. $34.95 list, 8½x11, 128p, 175 color photos, diagrams, index, order no. 1821.

ADVANCED STUDIO LIGHTING TECHNIQUES

FOR DIGITAL PORTRAIT PHOTOGRAPHERS

Norman Phillips

Learn to adapt traditional lighting setups to create cutting-edge portraits with a fine-art feel. $34.95 list, 8½x11, 128p, 126 color photos, diagrams, index, order no. 1822.

PROFESSIONAL MARKETING & SELLING TECHNIQUES

FOR DIGITAL WEDDING PHOTOGRAPHERS, SECOND EDITION

Jeff Hawkins and Kathleen Hawkins

Taking great photos isn't enough to ensure success! Become a master marketer and salesperson with these easy techniques. $34.95 list, 8½x11, 128p, 150 color photos, index, order no. 1815.

THE BEST OF TEEN AND SENIOR PORTRAIT PHOTOGRAPHY

Bill Hurter

Learn how top professionals create stunning images that capture the personality of their teen and senior subjects. $34.95 list, 8½x11, 128p, 150 color photos, index, order no. 1766.

THE BEST OF ADOBE® PHOTOSHOP®

Bill Hurter

Rangefinder editor Bill Hurter calls on the industry's top photographers to share their strategies for using Photoshop to intensify and sculpt their images. No matter your specialty, you'll find inspiration here. $34.95 list, 8½x11, 128p, 170 color photos, 10 screen shots, index, order no. 1818.

HOW TO CREATE A **HIGH PROFIT PHOTOGRAPHY BUSINESS**
IN ANY MARKET

James Williams

Identify your ideal client type, create the images they want, and watch your financial and artistic dreams spring to life! $34.95 list, 8½x11, 128p, 200 color photos, index, order no. 1819.

THE BEST OF FAMILY PORTRAIT PHOTOGRAPHY

Bill Hurter

Acclaimed photographers reveal the secrets behind their most successful family portraits. Packed with award-winning images and helpful techniques. $34.95 list, 8½x11, 128p, 150 color photos, index, order no. 1812.

DIGITAL PHOTOGRAPHY BOOT CAMP

Kevin Kubota

Kevin Kubota's popular workshop is now a book! A down-and-dirty, step-by-step course in building a professional photography workflow and creating digital images that sell! $34.95 list, 8½x11, 128p, 250 color images, index, order no. 1809.

THE ART OF BLACK & WHITE PORTRAIT PHOTOGRAPHY

Oscar Lozoya

Learn how master photographer Oscar Lozoya uses unique sets and engaging poses to create black & white portraits that are infused with drama. Includes lighting strategies, special shooting techniques, and more. $29.95 list, 8½x11, 128p, 100 duotone photos, order no. 1746.

BEGINNER'S GUIDE TO PHOTOGRAPHIC LIGHTING

Don Marr

Create high-impact photographs of any subject with Marr's simple techniques. From edgy and dynamic to subdued and natural, this book shows how to get the myriad effects you're after. $29.95 list, 8½x11, 128p, 150 color photos, index, order no. 1785.

PROFESSIONAL POSING TECHNIQUES FOR WEDDING AND PORTRAIT PHOTOGRAPHERS

Norman Phillips

Master the techniques you need to pose subjects successfully—whether you are working with men, women, children, or groups. $34.95 list, 8½x11, 128p, 260 color photos, index, order no. 1810.

ALSO BY JEFF SMITH . . .

OUTDOOR AND LOCATION PORTRAIT PHOTOGRAPHY, 2nd Ed.

Learn to work with natural light, select locations, and make clients look their best. Packed with step-by-step discussions and illustrations to help you shoot like a pro! $34.95 list, 8½x11, 128p, 80 color photos, index, order no. 1632.

CORRECTIVE LIGHTING, POSING & RETOUCHING
FOR DIGITAL PORTRAIT PHOTOGRAPHERS, 2nd Ed.

Learn to make every client look his or her best by using lighting and posing to conceal real or imagined flaws—from baldness, to acne, to figure flaws. $34.95 list, 8½x11, 120p, 150 color photos, order no. 1711.

SUCCESS IN PORTRAIT PHOTOGRAPHY

Many photographers realize too late that camera skills alone do not ensure success. This book will teach photographers how to run savvy marketing campaigns, attract clients, and provide top-notch customer service. $29.95 list, 8½x11, 128p, 100 color photos, order no. 1748.

PROFESSIONAL DIGITAL PORTRAIT PHOTOGRAPHY

Because the learning curve is so steep, making the transition to digital can be frustrating. Author Jeff Smith shows readers how to shoot, edit, and retouch their images—while avoiding common pitfalls. $29.95 list, 8½x11, 128p, 100 color photos, order no. 1750.

POSING FOR PORTRAIT PHOTOGRAPHY
A HEAD-TO-TOE GUIDE

Author Jeff Smith teaches surefire techniques for fine-tuning every aspect of the pose for the most flattering results. Before-and-after photos make it easy to master each skill. $34.95 list, 8½x11, 128p, 150 color photos, index, order no. 1786.

PROFITABLE PORTRAITS
THE PHOTOGRAPHER'S GUIDE TO CREATING PORTRAITS THAT SELL

By learning how to design images that are precisely tailored to your clients' tastes, you can begin creating portraits that will practically sell themselves! $29.95 list, 8½x11, 128p, 100 color photos, index, order no. 1797.

DIGITAL PORTRAIT PHOTOGRAPHY OF
TEENS AND SENIORS

Patrick Rice

Learn the techniques top professionals use to shoot and sell portraits of teens and high-school seniors! Includes tips for every phase of the digital process. $34.95 list, 8½x11, 128p, 200 color photos, index, order no. 1803.

THE BEST OF PHOTOGRAPHIC LIGHTING

Bill Hurter

Top professionals reveal the secrets behind their successful strategies for studio, location, and outdoor lighting. Packed with tips for portraits, still lifes, and more. $34.95 list, 8½x11, 128p, 150 color photos, index, order no. 1808.

MARKETING & SELLING TECHNIQUES

FOR DIGITAL PORTRAIT PHOTOGRAPHY

Kathleen Hawkins

Great portraits aren't enough to ensure the success of your business! Learn how to attract clients and boost your sales. $34.95 list, 8½x11, 128p, 150 color photos, index, order no. 1804.

THE PORTRAIT PHOTOGRAPHER'S
GUIDE TO POSING

Bill Hurter

Posing can make or break an image. Now you can get the posing tips and techniques that have propelled the finest portrait photographers in the industry to the top. $34.95 list, 8½x11, 128p, 200 color photos, index, order no. 1779.

MASTER LIGHTING GUIDE

FOR PORTRAIT PHOTOGRAPHERS

Christopher Grey

Efficiently light executive and model portraits, high and low key images, and more. Master traditional lighting styles and use creative modi-fications that will maximize your results. $29.95 list, 8½x11, 128p, 300 color photos, index, order no. 1778.

POWER MARKETING FOR WEDDING AND PORTRAIT PHOTOGRAPHERS

Mitche Graf

Set your business apart and create clients for life with this comprehensive guide to achieving your professional goals. $29.95 list, 8½x11, 128p, 100 color images, index, order no. 1788.

THE PORTRAIT BOOK

A GUIDE FOR PHOTOGRAPHERS

Steven H. Begleiter

A comprehensive textbook for those getting started in professional portrait photography. Covers every aspect from designing an image to executing the shoot. $29.95 list, 8½x11, 128p, 130 color images, index, order no. 1767.

THE BEST OF PORTRAIT PHOTOGRAPHY

Bill Hurter

View outstanding images from top professionals and learn how they create their masterful images. Includes techniques for classic and contemporary portraits. $29.95 list, 8½x11, 128p, 200 color photos, index, order no. 1760.

GROUP PORTRAIT PHOTOGRAPHY HANDBOOK,

2nd Ed.

Bill Hurter

Featuring over 100 images by top photographers, this book offers practical techniques for composing, lighting, and posing group portraits—whether in the studio or on location. $34.95 list, 8½x11, 128p, 120 color photos, order no. 1740.